L'ORANGERIE GUIDE

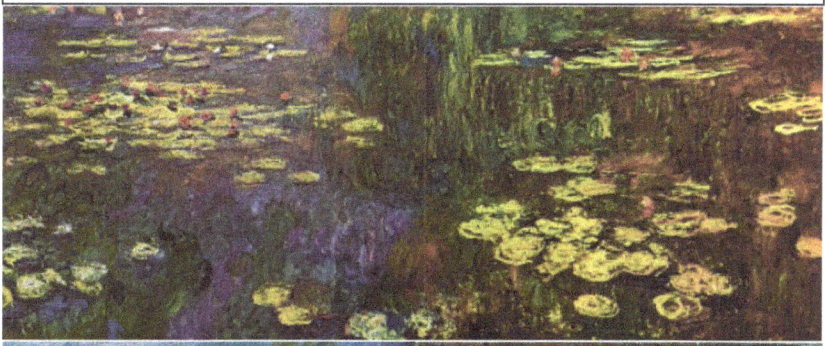
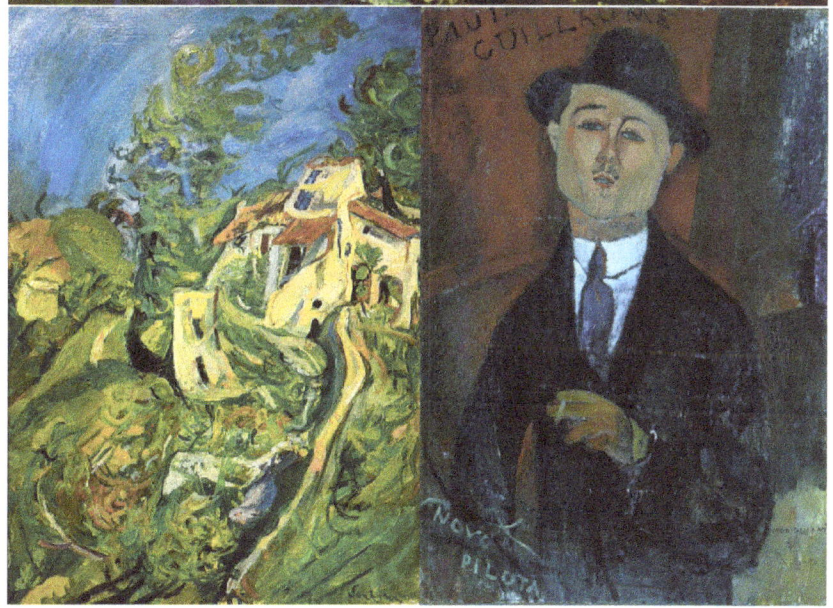

INDEX

- Schedules: ... 8
- Rates ... 8
- Carte Blanche ... 8
- Collections ... 12
- CLAUDE MONET ... 13
 - Argenteuil .. 13
 - Monet's Water Lilies 14
- Walter-Guillaume Collection 24
 - A collection full of mystery: 26
- CEZANNE (Level -1 Room 2) 26
 - Trees and Houses ... 29
 - Straw vase, sugar bowl and apples 29
 - Flowers and fruits. Flowers in a Blue Vase 31
 - Apples and Biscuits .. 31
 - Still life, pear and green apples 31
 - The Pine of Estaque 32
 - The Red Rock ... 33
 - Portrait of the artist's son 33
 - The Boat and the Bathers 34
 - The Luncheon on the Grass 34
 - In the grounds of Château Noir 35
 - Portrait of Madame Cézanne 35
 - Madame Cézanne in the garden 36
- RENOIR .. 36
 - Woman leaning on her elbows 37
 - Woman with a Hat .. 38
 - Blonde Girl with a Rose 38
 - Nude woman in a Landscape 38
 - Seated Bather drying her leg 39

- Bather with long hair ... 39
- Nude woman lying down ... 39
- Claude Renoir as a clown ... 40
- Gabrielle in the garden ... 40
- Claude Renoir, playing ... 41
- Gabrielle Renard and Infant son, Jean ... 41
- Young girls on the piano ... 41
- Yvonne and Christine Lerolle at the piano ... 42
- Portrait of two little girls ... 43
- Woman with a Letter ... 43
- Portrait of a young man and a young girl ... 43
- Flowers in a vase ... 44
- Bouquet ... 44
- Tulip bouquet ... 45
- Bouquet in a box ... 45
- Strawberries ... 46
- Apples and pears ... 46
- Peaches ... 46
- Snow landscape ... 48

ALFRED SISLEY (1839 - 1899) ... 48
- Your style ... 49
- Le Chemin de Montbuisson à Louveciennes (1875) ... 50

HENRY ROUSSEAU ... 50
- The Cliff ... 51
- The Ship in the Storm ... 52
- Fishermen ... 52
- The Carriage of Father Junier ... 52
- The Wedding ... 54
- The Child with the Doll ... 54
- The Chair Factory in Alfortville ... 54

GAUGUIN ... 55
- Landscape ... 57

AMADEO MODIGLIANI ... 57
- The Young Apprentice ... 58
- Red-haired girl ... 58
- Woman with Velvet Ribbon ... 58
- Antonia ... 60
- Paul Guillaume (Novo Pilota) ... 60

CHAIM SOUTINE ... 60
- The White House ... 60
- Landscape ... 61
- The Houses ... 61
- Landscape with figures ... 61
- The Village ... 63
- The Big Blue Tree ... 63
- Turkey and tomatoes ... 64
- Still life with pheasant ... 64
- Beef and calf's head ... 64
- The Plucked Chicken ... 65
- The Turkey ... 65
- The Rabbit ... 66
- The Table ... 66
- Gladioli ... 67
- The Bride ... 68
- The Best Man ... 68
- Portrait of a man (Émile Lejeune) ... 68
- The Floor Waiter ... 69
- The Little Pastry Chef ... 69
- The Choirboy ... 69
- The Young Anglaise ... 71

HENRI MATISSE ... 71
- Reclining nude with a drape ... 72
- Woman with Mandolin ... 72
- Woman with Violin ... 72
- The Three Sisters ... 73
- Women on the Sofa or Couch ... 73
- The Boudoir ... 73
- Odalisque in Red Trousers ... 73
- Blue Odalisque or The White Slave ... 73
- Odalisque in Gray Trousers ... 73

ANDRÉ DERAIN ... 74
- The Golden Age ... 74
- Landscape of Provence ... 75
- Landscape of the South ... 75
- The Road ... 75
- The Big Tree ... 75
- La Gibecière ... 76
- Still life with Basket ... 76
- Still life with a glass of wine ... 76
- Pears and Jug ... 76
- The Kitchen Table ... 76
- Country still life ... 76
- Melon and fruits ... 77
- Roses on a Black Background ... 77
- Roses in a Vase ... 77
- Nude on the Sofa ... 77
- Large Reclining Nude ... 77
- Nude with Jug ... 77
- The Beautiful Model ... 78
- The Dancer Sonia ... 78

- The Painter's Niece ... 78
- The Painter's Niece Seated ... 78
- Portrait of Madame Paul Guillaume with the big hat ... 78
- Portrait of Paul Guillaume ... 79
- Harlequin and Pierrot ... 79
- Harlequin on guitar ... 79
- The Black Man with the Mandolin ... 79

PICASSO ... 80
- Woman in a White Hat ... 80
- The Embrace ... 81
- The Adolescents ... 81
- Three Women at the Fountain ... 81
- Large nude in the drapery ... 81
- Large Bather ... 81
- Woman with a Comb ... 81
- Nude on a Red Background ... 81
- Woman with Tambourine ... 82
- Large Still Life ... 82
- Composition: Peasants (1906) ... 82

MAURICE UTRILLO ... 82
KEES VAN DONGEN ... 83
MARIE LAURENCIN ... 83

L'ORANGERIE GUIDE

The museum houses an impressive collection of paintings impressionists and post-impressionists by prestigious authors such as: Monet, Renoir, Cézanne, Alfred Sisley, Henri Rousseau (Le Douanier), Amedeo Modigliani, Chaïm Soutine, Matisse and Picasso, Maurice Utrillo, André Derain, Marie Laurencin and Van Dongen.

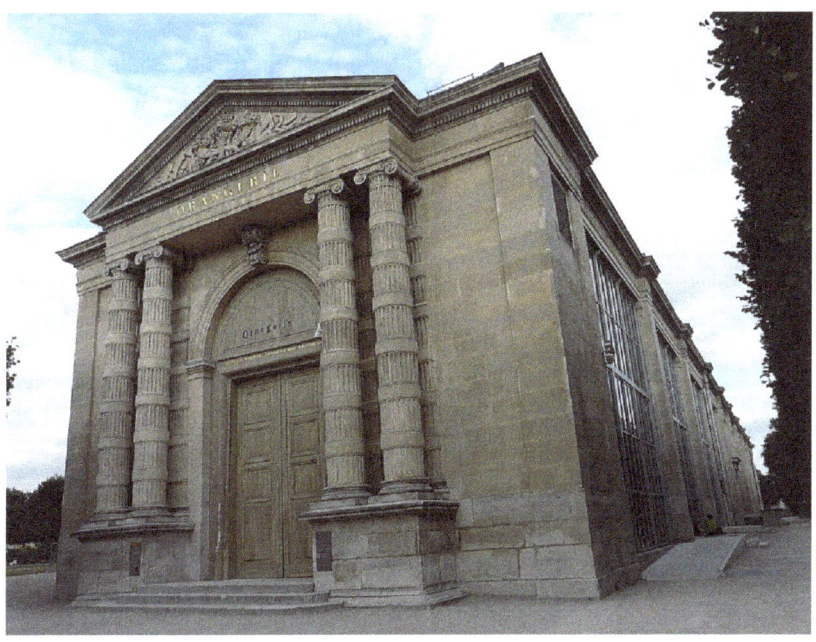

It is located in the **Tuileries Garden,** on the banks of the Seine River, in what was an old orangery, from which it derives its name in French. The building was built by Napoleon III in 1852. It is located within the gardens of the Tuileries Palace. Its purpose was to serve as an orangery, and it was designed by Bourgeois and Louis Visconti. Large windows opened to the Seine River.

Later, it had different uses: warehouse, school and temporary barracks.

In 1921 it became an annex to the Luxembourg Museum.
In 1965, the architect Olivier Lahalle raised the building on two levels, and a monumental staircase was built, modifying the access room to the Water Lilies.

Finally, in the 1980s, La Orangerie became a national museum, independent of the Louvre.

L'ORANGERIE GUIDE

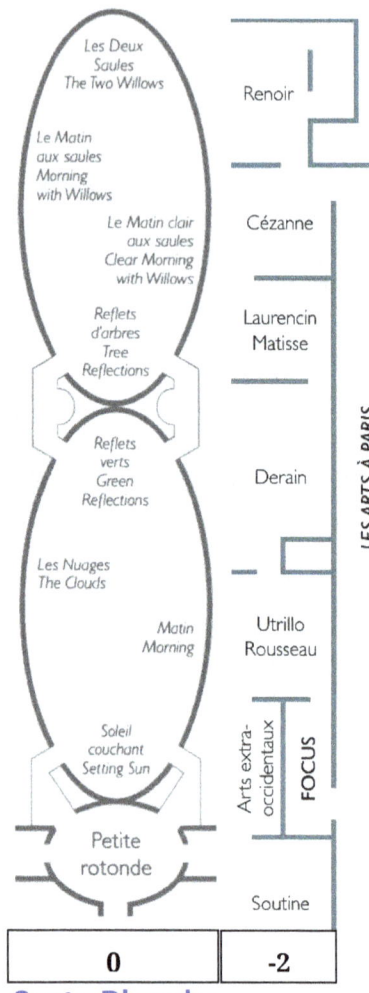

The museum has 3 levels: 0, -1 and -2.
-**Claude Monet's water lilies** are located on the ground floor (level 0).
-On level -1, here is the cafeteria and the souvenir shop.
-The **Jean Walter-Paul Guillaume collection** is located on level -2.

Schedules:
-From Tuesday to Sunday, from 9 a.m. to 6 p.m.
Deadline to enter: 5:15 p.m.
The rooms close at 5:45 p.m.
-Closed: Tuesday, May 1, July 14 in the morning, and December 25.

Rates
-**Normal rate**: €12.50
-**Reduced rate:** €10
-**Reduced "Enfant et Cie" rate,** for a maximum of 2 adults, legal residents of the European Union, accompanying a minor under 18 years of age.
-**Combined rate: Orangerie + Orsay Museum** (can be used within 3 days of purchase. Valid for one access to each museum).
-**Free rate**: first Sunday of each month. It cannot be purchased at the ticket counters. Online reservation is mandatory, indicating a fixed schedule.

Carte Blanche
Card that allows you unlimited access to the Orsay Museum and the Orangerie Museum, for the duration of your subscription.
Preferential access and without waiting in line. 10% discount in the restaurant and souvenir shop; 5% discounts on books.
Guided tours and audio guide rentals also have discounts.
Members have reduced rates at the Museums of Paris, including the Rodin Museum, the Impressionist Museum of Giverny, the Théâtre de la Colline and the transport network of the Ile-de-France.

L'ORANGERIE GUIDE

Bi-monthly newsletter with information on museum exhibitions and special offers for members at Paris shows.

Orsay Museum, entrance through gate A1 from 9:00 a.m.

1 year modality
-General individual: €52.
-General duo: €79. (for two people)
-Young individual: €25.
-Young duo: €40. (for two young people)

2 year modality
-General individual: €95.
-General duo: €145. (for two people).
-Young individual: €45.
-Young duo: €74. (for two young people).

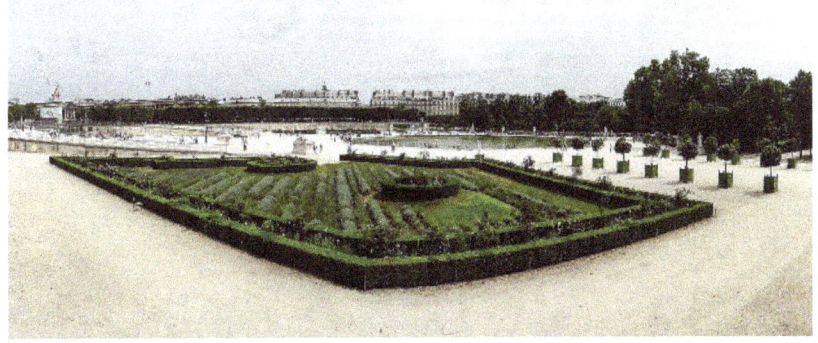

You can submit the membership form by mail, and you will receive your carte blanche by post. If you hand in the form at the museum ticket office, you will receive your carte blanche on the spot.

Official website: www.musee-orangerie.fr ·
Telephone: +33 1 44 50 43 00

-It is advisable to purchase tickets online well in advance.
Entry tickets purchased online have priority access during the 30 minutes following the reserved time.

-Minimum recommended time for the visit: from 1 hour and 30 minutes to 2 hours.

Location: between Place de la Concorde and the Louvre Museum.

L'ORANGERIE GUIDE

(Located about 250 meters from the Place de la Concorde, and about 350 meters from the Jardin des Tuileries).
Nearest metro stations: Concorde and Tuileries.
Museum access
•Door at the intersection between rue de Rivoli and Place de la Concorde.
•Door at the intersection between rue de Castiglione and rue de Rivoli.
•Door on rue de Rivoli at rue du 29 juillet (near the Tuileries metro station)
•Sédar Senghor footbridge door (Quai des Tuileries)

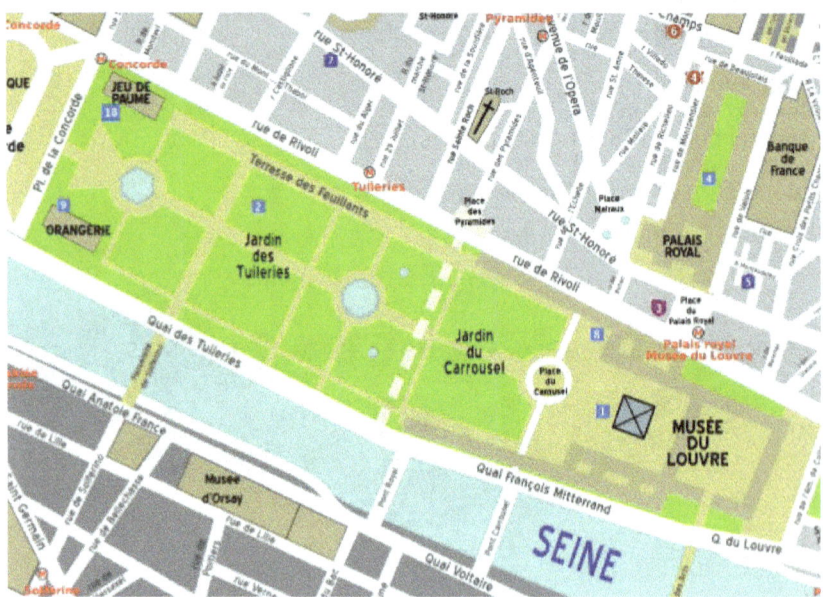

Metro/RER: Lines 1, 8, 12, Concorde station
Bus: lines 24, 42, 45, 52, 72, 73, 84, 94, Concorde stop.

Vélib Stations:
Cambon-Rivoli (no. 1020), Assemblée Nationale (no. 7009), Quai Anatole France-Musée d'Orsay (no. 7110), Quai d'Orsay-Invalides (no. 7112), Place de la Concorde (corner avenue Gabriel and place de la Concorde), Pyramides (15, rue des Pyramides), Carrousel du Louvre (access via avenue du Général Lemonnier).
Vélib is a self-service service for mechanical (green) and electric (blue) bicycles available 24 hours a day in Paris and its metropolitan area, with more than 1,400 stations.
-Prices for occasional users:
•30 minutes/€1. Additional 30 minutes: €2.
•45 minutes/€3.Additional 45 minutes: €2.

L'ORANGERIE GUIDE

- 24-hour pass on mechanical bicycles/5€.
- 24-hour pass on electric bicycles/€10.
- 72 hour pass/€20.

https://www.velib-metropole.fr/offers#p

• It is prohibited to ride unicycles or two-wheeled vehicles in the Tuileries Garden

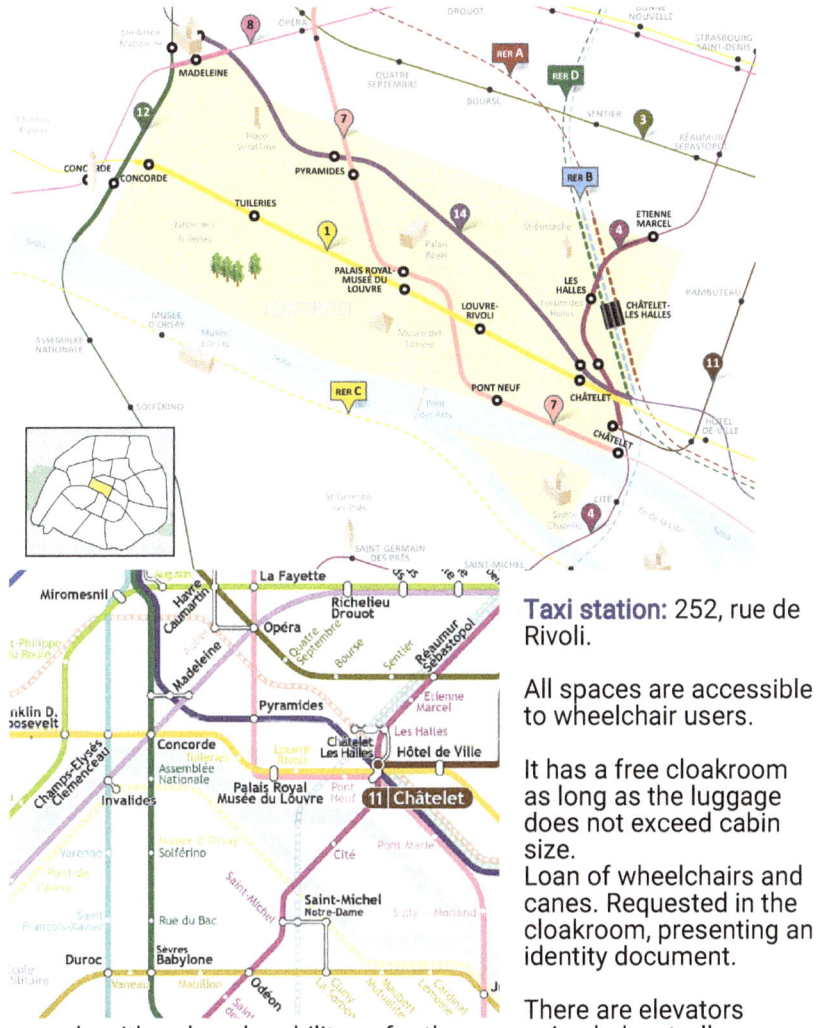

Taxi station: 252, rue de Rivoli.

All spaces are accessible to wheelchair users.

It has a free cloakroom as long as the luggage does not exceed cabin size.

Loan of wheelchairs and canes. Requested in the cloakroom, presenting an identity document.

There are elevators for people with reduced mobility or for those carrying baby strollers.

L'ORANGERIE GUIDE

On **level -2** there is a water fountain in the toilet hall, and two spaces for babies: one in the women's toilets (near of the auditorium), and another in the mixed toilets (near the workshop).

Lost and found
Telephone: +33 (0) 1 44 50 43 00
email: information@musee-orangerie.fr

-Free Wi-Fi throughout the museum: **Museo_Orangerie_Público**
information@musee-orangerie.fr

Collections

-Paul Cézanne (1839 - 1906, Aix-en-Provence, France)
 • Portrait of Madame Cézanne (1890)

-Alfred Sisley (1839 - 1899 Moret-sur-Loing, France)

-Claude Monet (1840 - 1926 Giverny, France)
 • Les nymphéas (1895 - 1926)
 • The clouds (1923-1926)

-Auguste Renoir (1841 - 1919 Cagnes-sur-mer, France)
 • Femme nue dans un paysage (1883)
 • Portrait de deux fillettes (1892)
 • Baigneuse aux cheveux longs (1896)
 • Yvonne and Christine Lerolle au piano (1898)
 • Femme nue couchée (Gabrielle) (1907)
 • Claude Renoir in clown (1909)
 • Femme accoudée (1919)

L'ORANGERIE GUIDE
- **Henri Rousseau, Le Douanier** (1844 - 1910 Paris, France)
 - La Carriole du Père Junier (1908)

- **Henri Matisse** (1869 - 1954 Nice, France)
- **Théodorus van Dongen** (1877 - 1968 Monaco)
- **André Derain** (1880 Chatou - 1954, Garche, France)
- **Pablo Picasso** (1881 - 1973 Mougins, France)
 - Great bather (1921-1922)

- **Marie Laurencin** (1883 Paris - 1956 Paris, France)
- **Amedeo Modigliani** (1884 - 1920 Paris, France)
 - Antonia (1915)

- **Chaïm Soutine** (1893 - 1943 Paris, France)
- **Maurice Utrillo** (1883 - 1955 Dax, France)

CLAUDE MONET
One of the creators of impressionism, which from its first realistic stage evolved to impressionism whose name derives from one of his paintings which he titled: Impression, rising sun (1872).

He always painted all his work outdoors, from his sketch to the end.
He exhibited his paintings together with Degas and Renoir.
In 1890 he began with repeated series of the same object with different lighting, which began a style closer to abstraction than realism, such as the Rouen cathedral and in 1906, the series of the lily pond of his house in Giverny, described by André Masson as the Sistine Chapel of Impressionism.

Light is the main element of his work, to which shapes and figures are subordinated. With his free, fast and loose brushstrokes he represents the effects of light on shapes and objects.
In his final years, Monet destroyed many of his unfinished works, as he did not want his sketches to be sold.
He was admired by Wassily Kandinsky and Marc Chagall described him as the Michelangelo of our time.

Argenteuil
This painting was acquired by Mrs. Domenica Walter and is the only work by Monet that belongs to the Guillaume-Walter collection.

It was painted in 1875 when Monet lived in Argenteuil, a fishing village located near Paris.
The strong contrast and the break in perspective stand out.

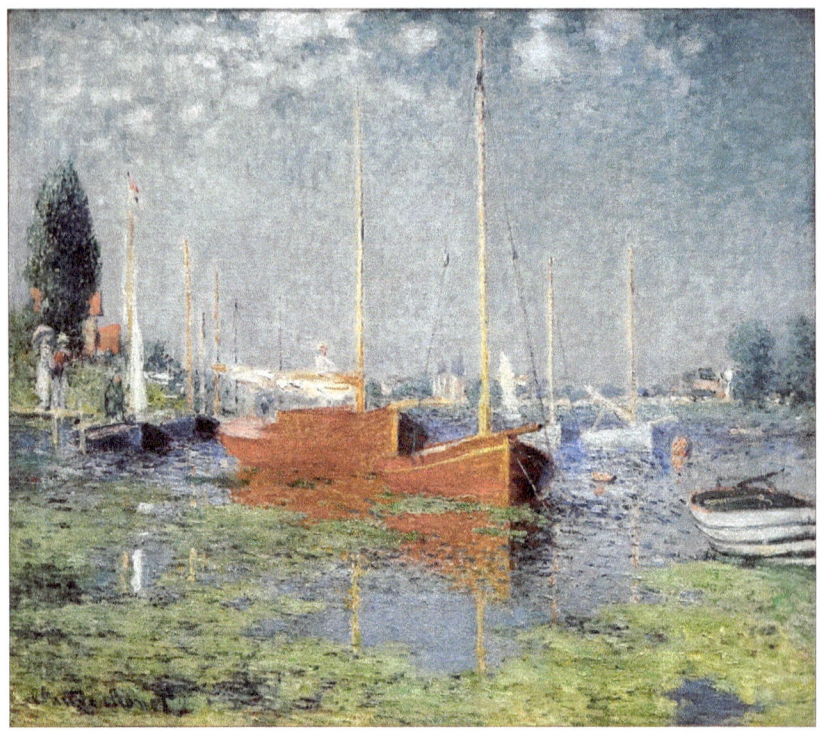

Monet's Water Lilies

The Prime Minister of France, **Georges Clemenceau**, a great friend of Monet, proposed to the painter that he create works that represented the arrival of peace after the end of the First World War.
Clemenceau convinced the reluctant Monet of the project, saying: "You owe this to France, especially to all those boys who will never return from the trenches."
He also proposed that the works be installed in the Orangerie, for which the building was rehabilitated, according to the design of Camille Lefèvre, architect of the Louvre, who created a large space with smooth walls and natural light, following the recommendations made by him himself.
painter.

L'ORANGERIE GUIDE

Claude Monet painted these paintings between 1916 and 1926, and in 1922, before completing his project, he donated Les Nymphéas (the Water Lilies) to the French State. The work is made up of a series of 8 large-format paintings that remained in Monet's possession until his death in 1926. The following year they were taken to the Orangerie and exhibited, for the first time, to the public.
In 2006 they were moved to the center of the ground floor of the building (level 0) and are exhibited in 2 rooms with an oval design, which form the symbol of infinity: ∞. The works are illuminated under a diffuse light, according to the artist's wishes.
On the rounded walls there are 8 gigantic panels from 6 to 17 meters wide and almost 2 meters high.

Between the 8 paintings they measure almost 100 meters in length, and 200 m² in surface.
They are considered the Sistine Chapel of Impressionist art.

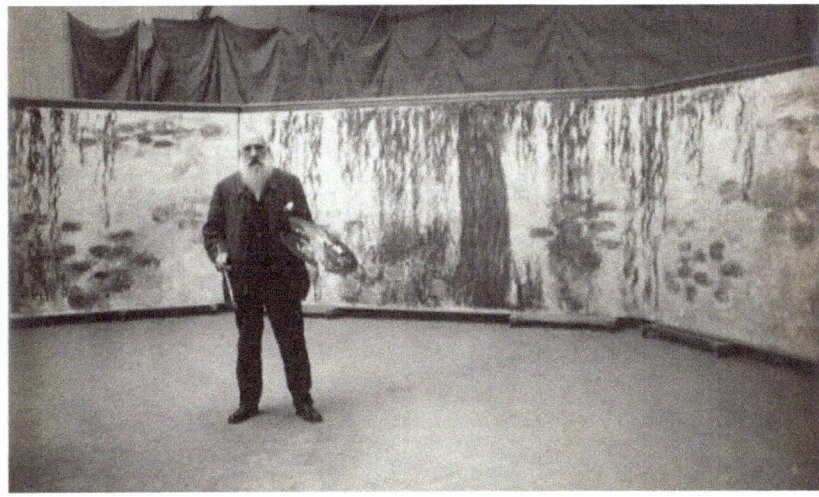

L'ORANGERIE GUIDE

Room 1:
1. Setting sun, **2.** Morning, **3.** The Clouds, **4.** Green reflections.

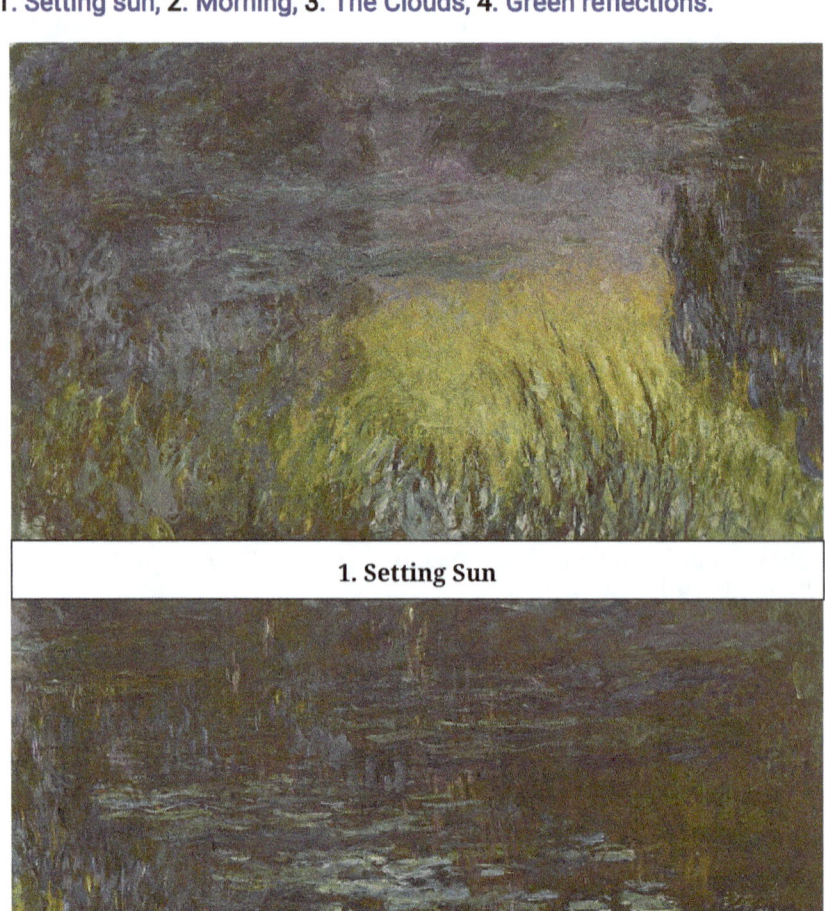

1. Setting Sun

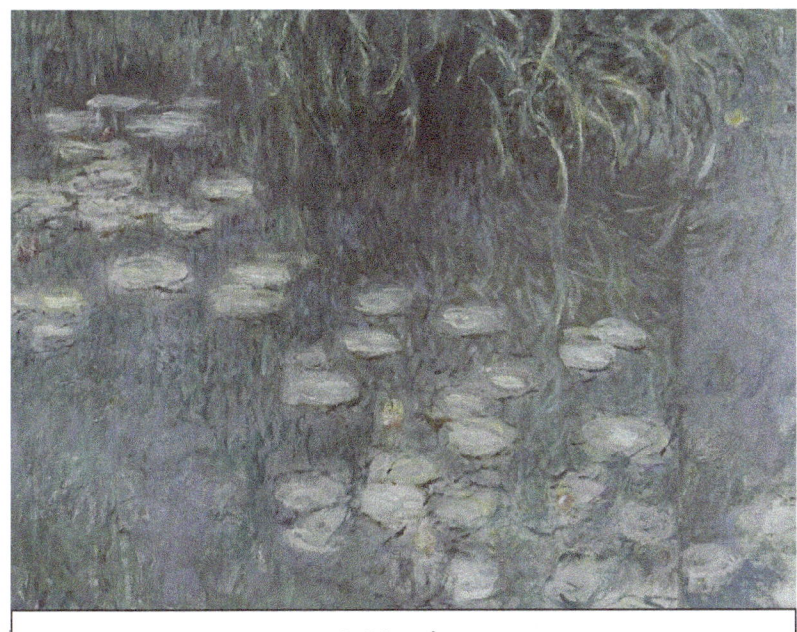

2. Morning

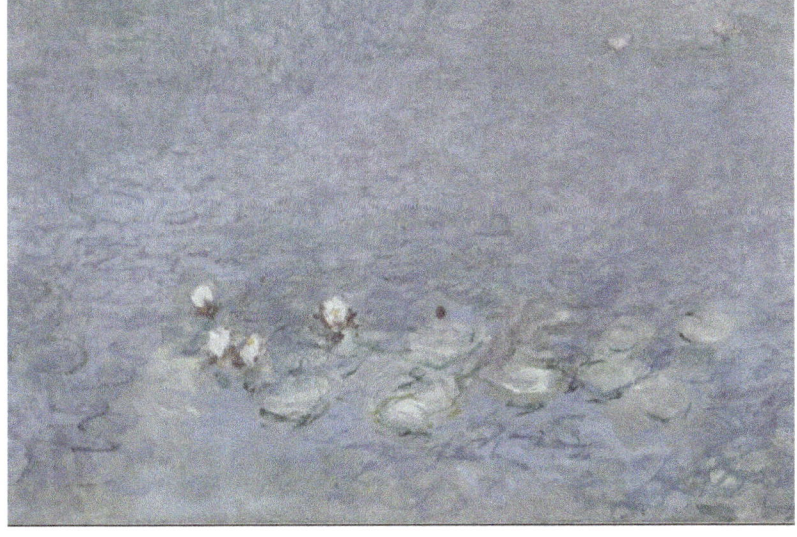

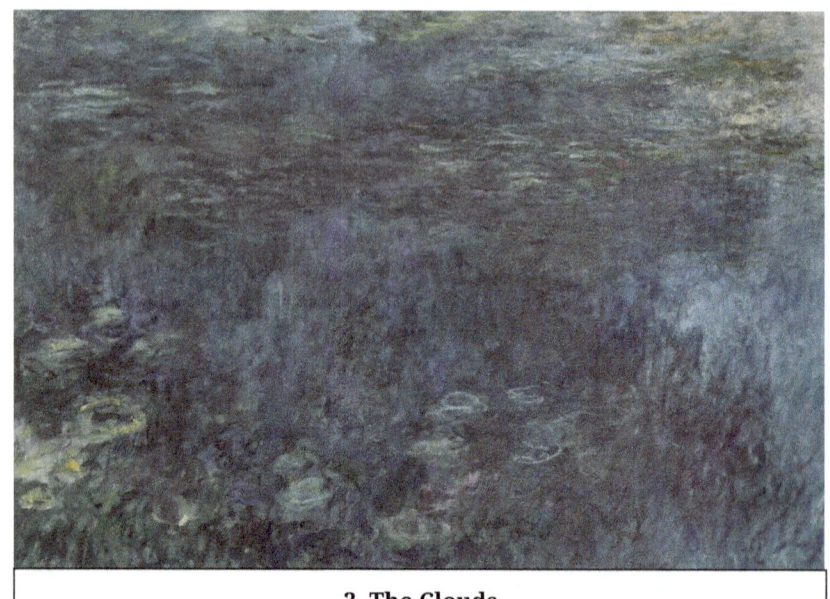

3. The Clouds

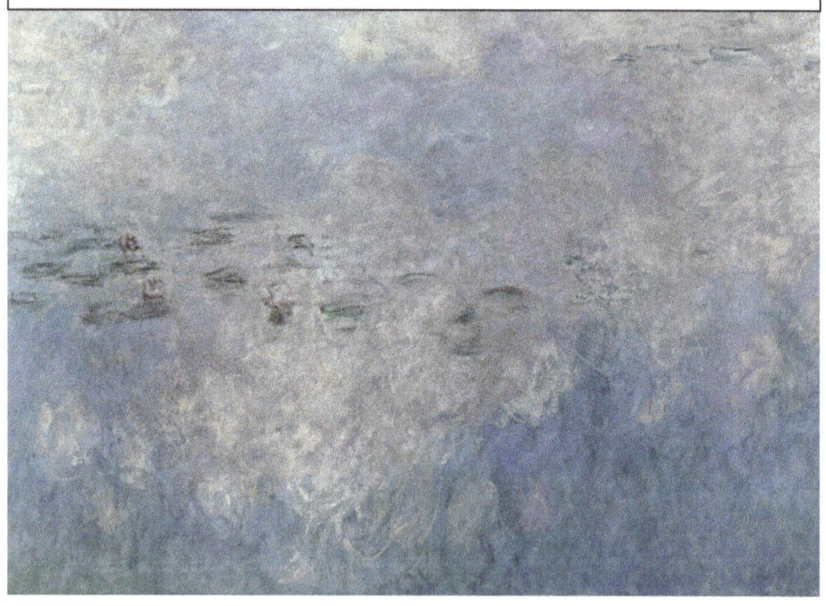

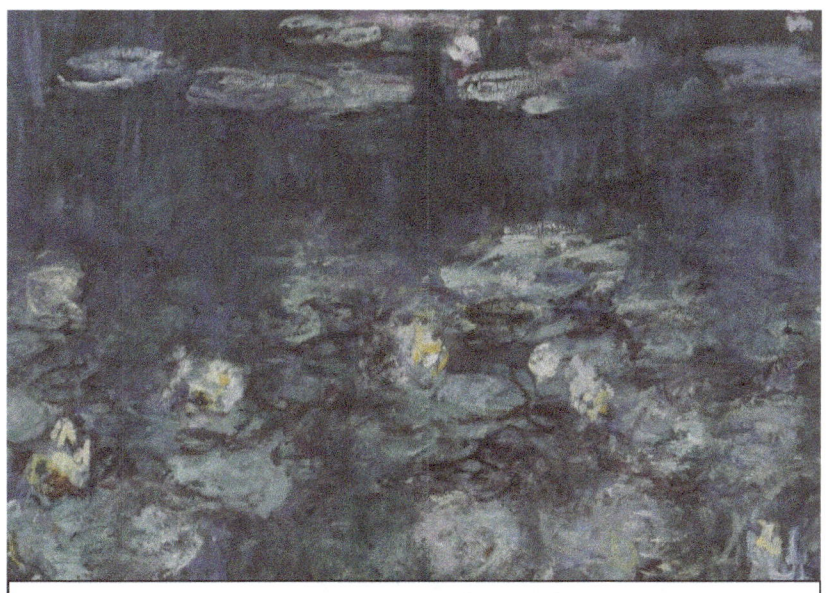

4. Green reflections

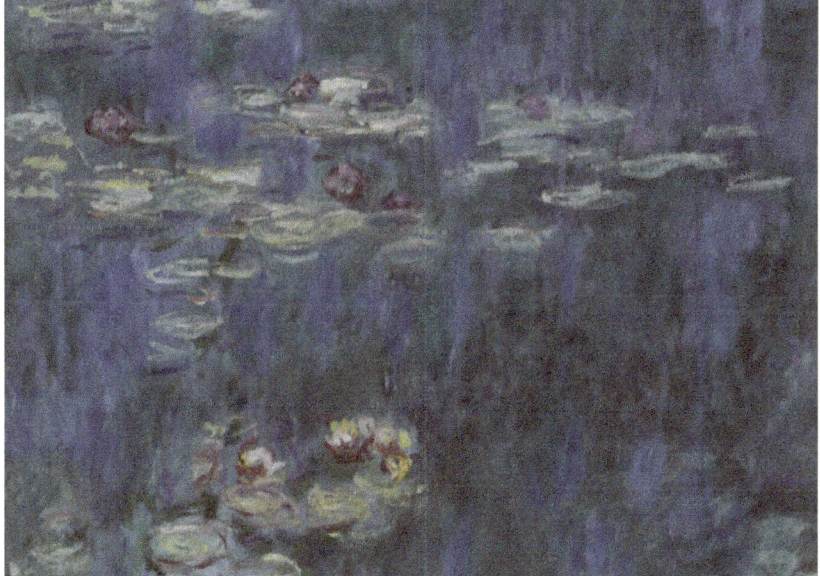

Room 2:
1. Tree reflections, 2. Clear morning with willows, 3. Morning with willows, 4. The Two willows.

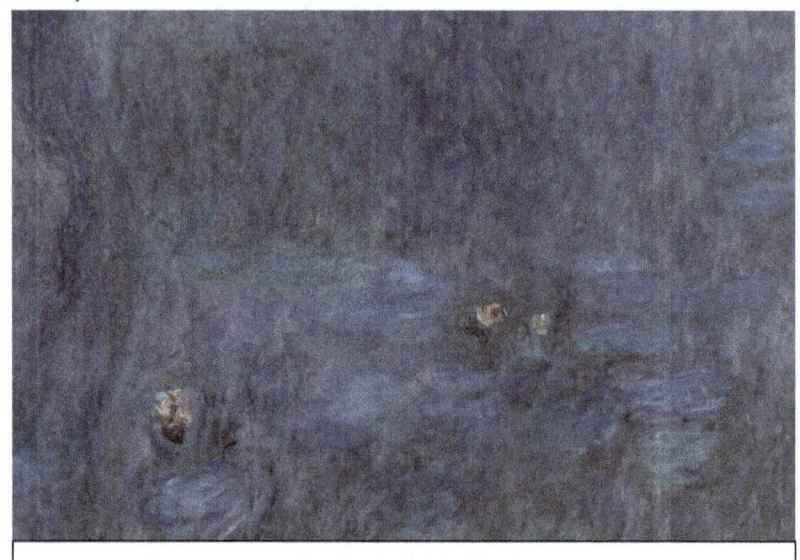

1. Tree reflections

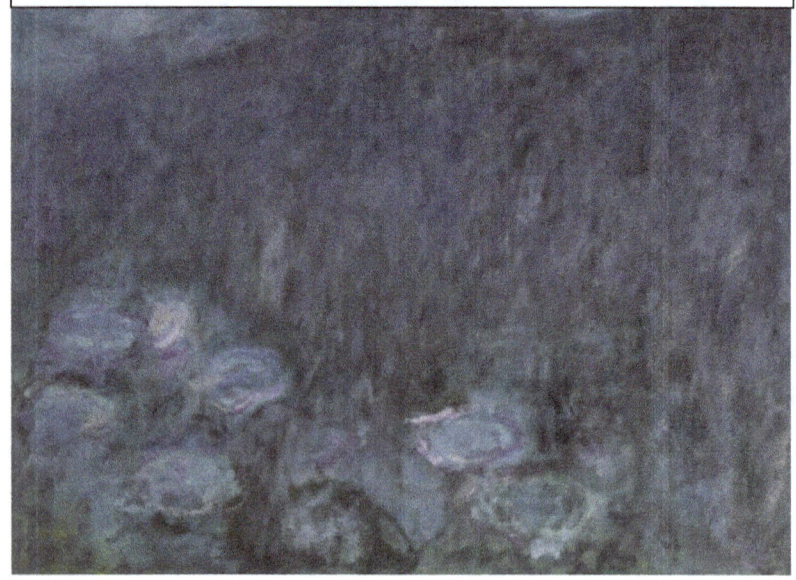

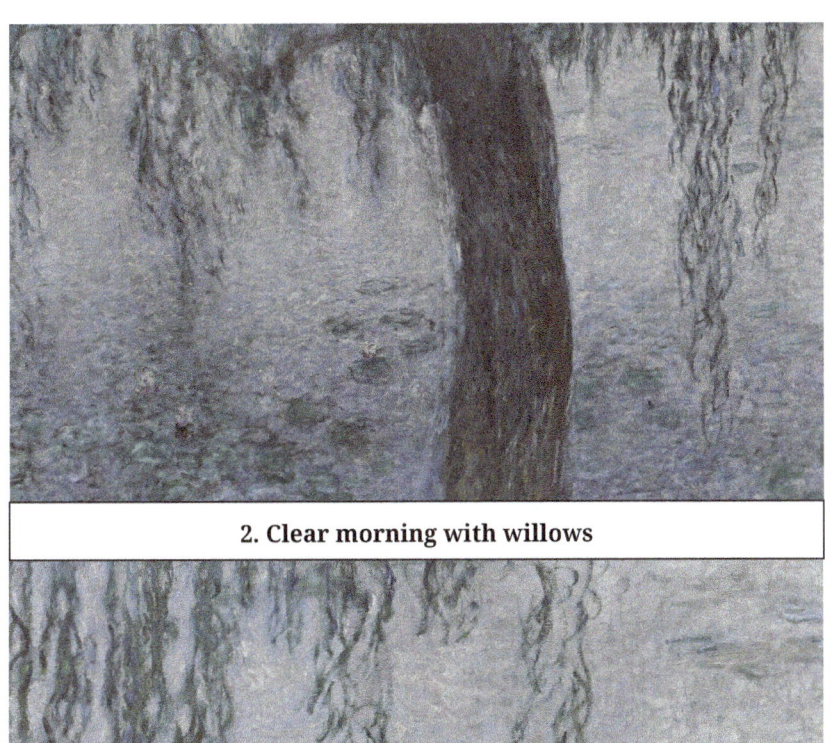

2. Clear morning with willows

L'ORANGERIE GUIDE

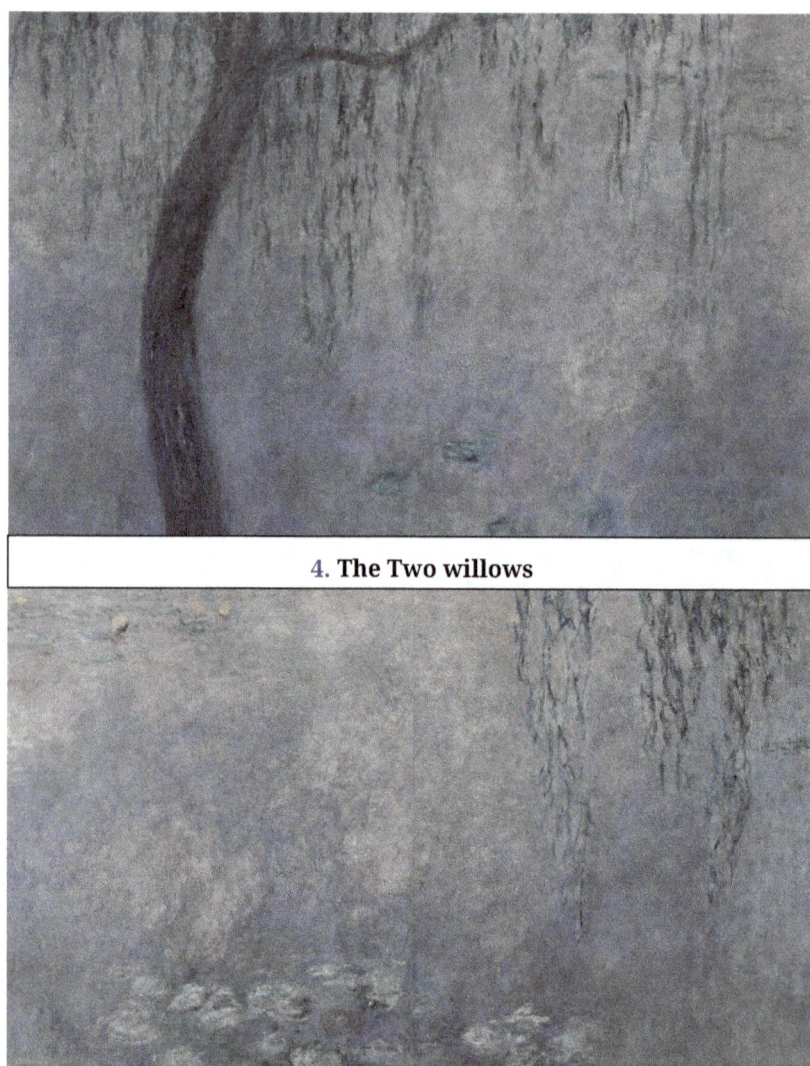

4. The Two willows

The water lilies represent the garden that the artist had in his home in **Giverny, (Normandy, France)** and were made to celebrate the end of the First World War.
The light-filled landscape envelops the visitor who finds himself in a garden of water lilies. All types of plants and an infinite blue sky are

reflected in the waters of the pond.

Monet represents, in his own words, an endless space, a gigantic wave without horizon or shore.

They aim to raise awareness in the world for serene reflection in search of eternal peace, after the most atrocious war that has ever been suffered before.

They are a universal symbol of eternal and imperishable peace.

Monet made numerous works on the same object, which he painted at different times of the day and with different lighting conditions, such as the Rouen Cathedral or his series of 250 paintings of Water Lilies that he made from 1900 until his death, of which 40 are by great size.

But among all his series of paintings, the one of Water Lilies that is exhibited in this museum stands out.

The painter acquired water lilies from Egypt and other parts of the world, and planted them in his garden in such quantities that he worried the neighbors, who reported him to the authorities for trying to poison the springs in the area.

Monet had a serious visual defect, but that did not prevent him from creating his masterpiece. When his son died, he fell into a deep depression, and took refuge in completing the gigantic project of the 19 panels of water lilies, for which he expanded his workshop. of paint and installs glass windows on the roof to let in more sunlight. As he himself said: "a moment of nature contains everything."

In the Orangerie, 8 of these panels are displayed, arranged according to the artist's wishes, located at the same height, and placed on the curved walls of the 2 oval rooms. The sunrises are in the east room; and the sunset, in the west room.

His desire for perfection was so extreme that in order to make numerous touch-ups to his works, he kept them in his workshop until his death, despite having transferred them to the State.

Claude Monet was born in Paris in 1840 and died in 1926, in Giverny, where he had his beautiful garden with water lilies. He went from realism to impressionism. His painting: Impression, rising sun, is what gives its name to this artistic style.

Although his work was admired by many art critics, others harshly criticized him because they attributed this new pictorial style not to a desire to innovate art but to his visual defect.

Despite the artist's considerable effort, his legacy was not widely

recognized until after World War II.
He is considered an artist who unites impressionism with new abstract art.

Walter-Guillaume Collection
The museum also houses the impressive Walter-
Guillaume, due to its exceptional quality, is the most important private art collection in the world.

It brings together 148 works that span from 1860 to 1930.
It is composed of 31 works by Derain, 25 by Renoir, 22 by Soutine, 15 by Cézanne, 12 by Picasso, 10 by Matisse, 10 by Utrillo, 9 by Rousseau, 7 by Laurencin, 5 by Modigliani, 1 work by Gauguin, Monet, Sisley and Van Dongen.

Paul Guillaume (1891-1934) was a wealthy businessman who is considered the most important art collector in France.
From a humble family, endowed with a natural talent for business and a sincere love for art, he began acquiring African art objects, which he exhibited in the family vehicle repair workshop. Something that attracted the famous French poet Apollinaire, who introduced him to Modigliani, Picasso and other artists, and advised him on the acquisition of many of the works.
Guillaume's fascinating personality attracted him the friendship of

politicians and wealthy businessmen. He soon opened the most important art gallery in Paris, and became a patron of unconsecrated artists, whom he supported and encouraged.

Guillaume's wife, **Juliette Lacaze**, nicknamed "Domenica the Diabolical", was endowed with great intelligence and charm. She worked as a wardrobe manager until she met Guillaume. She became the lover of the French millionaire, Jean Walter, something he was known for. her husband.

The collection is known today by the name of her two husbands: Guillaume-Walter.

In 1959, the widow signed a contract with the French State by which she sold the 146 paintings in the collection, reserving the right of ususfruct, which allowed Juliette Lacaze to sell part of the collection of African and Polynesian art, and acquire new works. by Renoir, Cezanne and Gauguin.

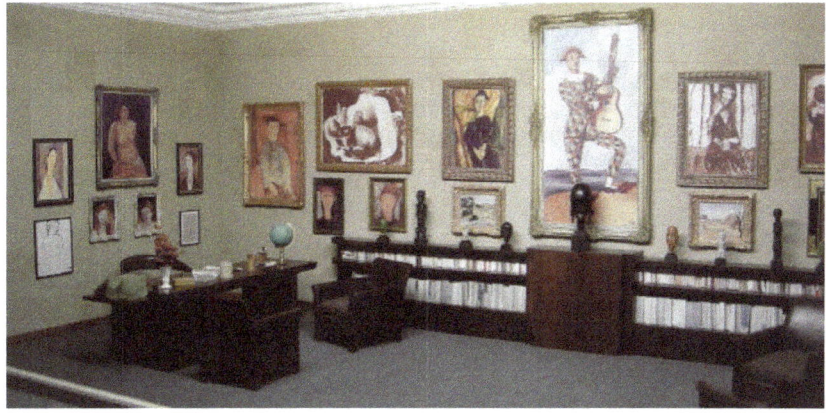

It was agreed that the collection would be exhibited in the Orangerie Museum, along with Monet's water lilies, thus fulfilling her husband's wishes. Juliette herself participated in the design of the rooms where the collection is displayed.

We can see it painted in a painting by André Derain that is in this museum.
Of the extensive collection, impressionist painting from the 19th and 20th centuries stands out. Works by Matisse, Modigliani and Giorgio Chirico, as well as cubist-style paintings by Picasso and numerous African sculptures acquired by Guillaume.

L'ORANGERIE GUIDE

A collection full of mystery:
Guillaume died prematurely at the age of 43, after receiving the legion of honor. In his will he transferred his art collection to the State, leaving his widow, **Juliette Lacaze**, the lifetime usufruct of the collection, which allows her to sell existing works, and acquire new works.

After the death of her second husband, Jean Walter, in a traffic accident, a brother and Juliette's new partner are accused of trying to murder her adopted son. It is rumored that to file the matter before Justice, Juliette sells the house. large collection of art to the French State for 135 million francs, retaining the usufruct until his death in 1977.

Temporary exhibition: "Paul Cézanne and Auguste Renoir: contemplating the world. Masterpieces from the collections of the Orangerie Museum." You can also see two paintings by Henri Rousseau on loan from the Orsay Museum.

CEZANNE (Level -1 Room 2)
French post-impressionist painter, considered the father of modern painting and whose works create the foundations between 19th century and 20th century art.
Cézanne creates the bridge between 19th century impressionism and the new style of the early 20th century, cubism.

The Academy of Fine Arts rejected him and they never bought his works in any official exhibition or museum because they did not respect perspective or anatomical correctness, considering that his figures were grotesque.

His work is influenced by Eugène Delacroix, Courbet and Manet.
Among his few friends is the writer Zola, as well as Guillaumin and Camille Pissarro.
Cézanne was a student of Pissarro, whom he deeply admired.

In 1870, Cézanne and his wife, the model Hortense Fuquet, fled France to avoid the painter's enlistment in the War against Prussia.
In 1872, they had a son and went to live in the house of the artistic patron

Dr. Gachet.
Between 1872 and 1873, Cézanne moved from dark colors to bright, intense colors, capturing scenes of rural life.

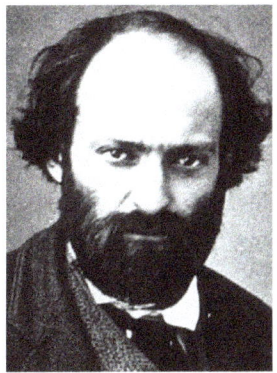

While he was painting in the field, a great storm hit, and the painter continued working for hours outdoors, which caused him pneumonia from which he died a few days later.
Only at the beginning of the 20th century, the importance of his work began to be appreciated.

He painted nature without any type of idealization, with the simplest forms. Small brushstrokes and planes of color come together to express sensations.

He strove to capture the complexity of human vision and its different points of view, representing the same object from different perspectives.

Two simultaneous and slightly different visual perceptions (vision of both eyes) give a perception of depth.

It simplifies the forms, and reduces them to the simplest geometric figures: sphere, cylinder, cone. Thus a tree trunk is a cylinder, a human head is a sphere.
He said: I want to make impressionism something lasting as museum art.

-Dark Period (1861-1870)
Use of dark colors, especially black, with thick and pasted pigments. It represents groups of large figures in a landscape. To this period belong: Portrait of Achille Emperador and Pastoral.

-Impressionist Period (1870-1878)
The most intense friendship with Pissarro stands out, who paints quickly and with touches of pure colors, without ever using previous sketches. Using this technique he seeks to capture the transience of light and natural objects.
His works are filled with lighter, more intense and luminous colors.
From this stage is the House of the Hanged Man, A Modern Olympia and Still Life of the Soup.

His work, a modern Olympia, was harshly criticized by academics who described it as a sketch of art, and even as wallpaper on a wall.

L'ORANGERIE GUIDE

-Period of Maturity (1878-1890)
He clearly distances himself from the impressionist style. He begins to draw figures from the comedy theater, card players and the Sainte-Victoire mountain.
From this period is the Maincy bridge and three bathers.

-Final Period (1890-1905)
Marked cubist characteristics can be seen in his paintings: stone quarries, landscapes, still lifes, portraits and naked bathers for which he used his wife, his son and village farmers as models.

The figure is so simplified that a few brush strokes are enough to express the volume. The intense color, skillfully united, represents the shapes and light.

Frustrated by the distortions that his use of color caused in the figures, he left most of his works unfinished, and destroyed many of them, especially those of bathers.
From this era are the famous card players, with 5 different versions, Woman with coffee pot, Still life with apples and oranges and Still life with onions.
He was greatly admired by Gauguin and Van Gogh.
His style is characterized by geometric simplification, visual effects and the use of color influenced Matisse and Picasso, who said that Cézanne is the father of us all.

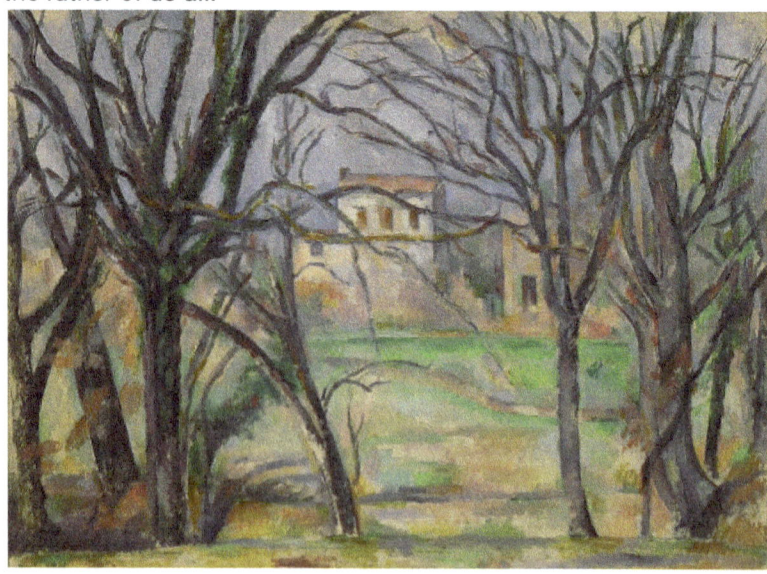

Trees and Houses

Cezanne paints his family home in Provence.
The tree branches are in the foreground and stand out for their dark colors.
In the center, the greenery of the meadow, and in the background, the houses and the sky, painted in lighter colors. The range of colors eliminates perspective.
This painting was acquired by Juliette Lacazze for the Guillaume-Walter collection.

Fruits, napkin and milk box

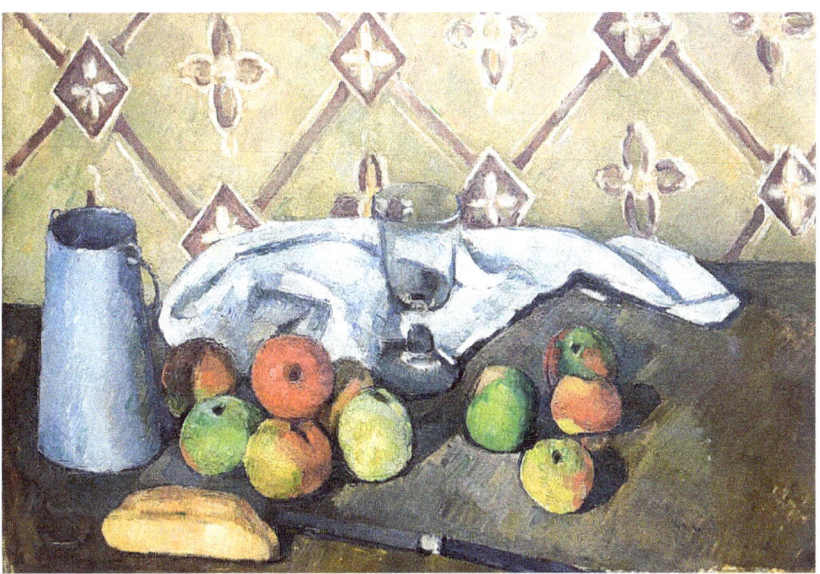

Straw vase, sugar bowl and apples

The objects are organized on a table seeking harmony, not real representation, highlighting the unusual viewing angle and the asymmetry in which they are arranged.
The plate on which the fruits are placed is so inclined that it gives the impression that the fruits are going to roll to the ground.

With delicate brushstrokes and subtle differences in tones, this painting genius creates the shapes of objects, which look like unfinished sketches.

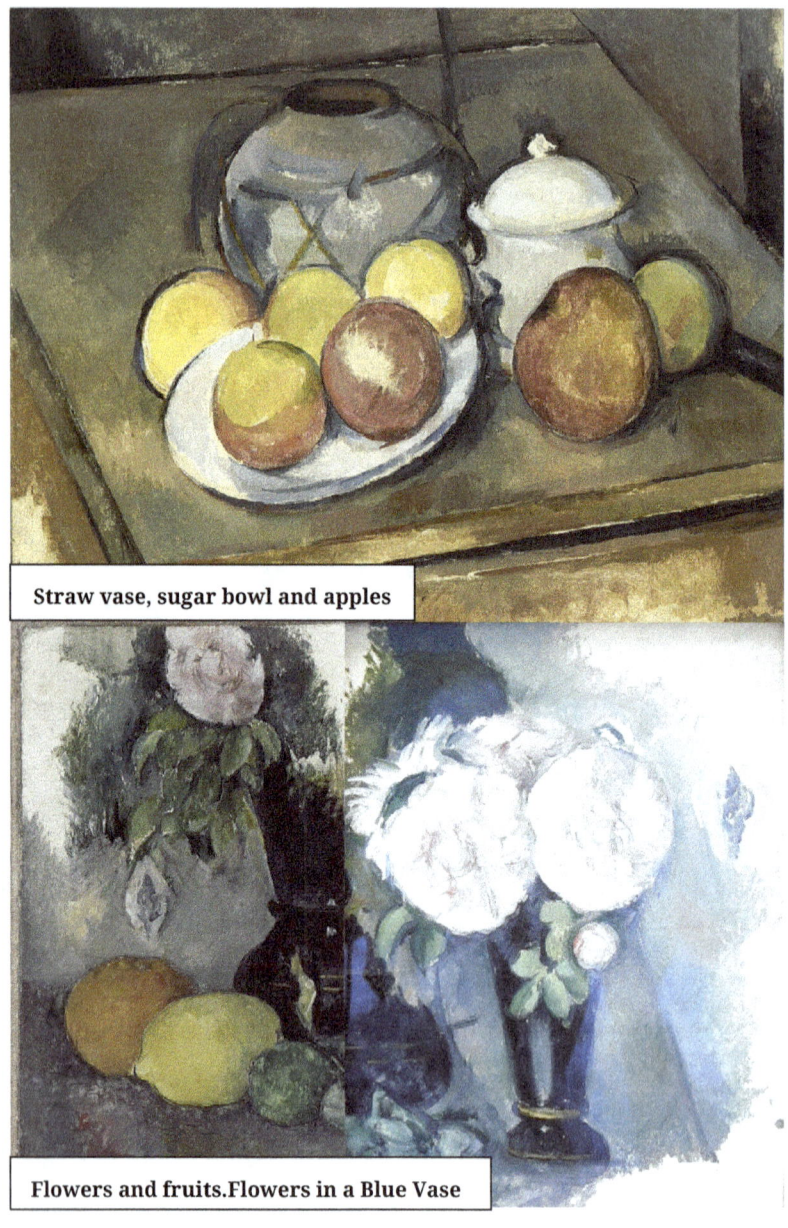

Straw vase, sugar bowl and apples

Flowers and fruits. Flowers in a Blue Vase

Flowers and fruits. Flowers in a Blue Vase
These two paintings were one that was divided to obtain more profitability. First Paul Guillaume acquired fleurs et fruits. Years later, his widow, Jacqueline Lacazze, bought Fleurs dans un vase bleu.

Apples and Biscuits
In this painting the perfect harmony of the objects stands out, constituting his masterpiece in this genre. In the words of the author, he said that with a single apple he would astonish France, and he achieved it. It was acquired by Jacqueline Lacazze for a high price.

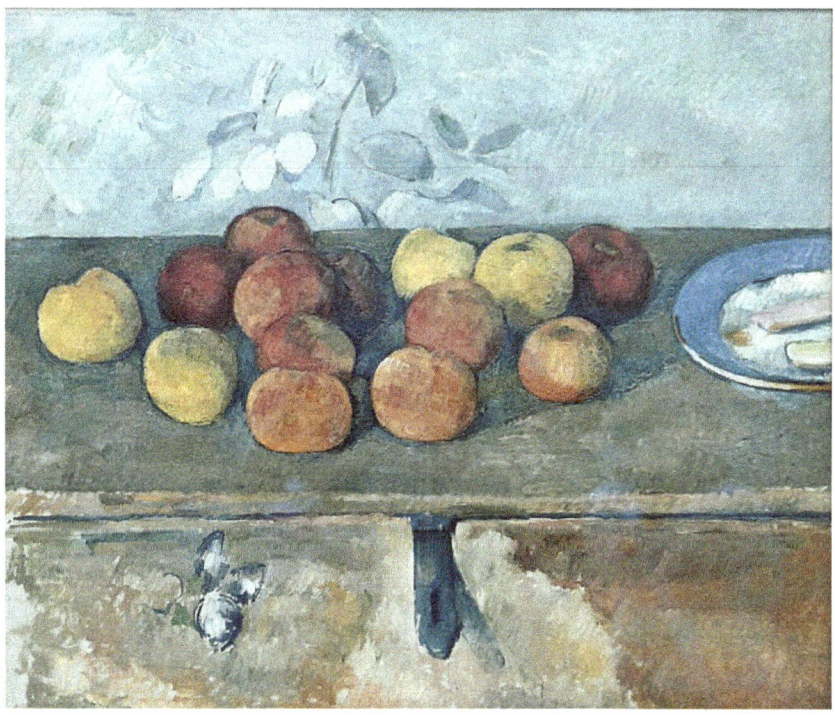

Still life, pear and green apples
The simplicity of the composition stands out. A pear and an apple, next to two other smaller, indistinguishable fruits.
Some experts have suggested that the painting was not painted by Cezanne but by Paul Gachet (1873-1962), son of Doctor Gachet, the

great art collector, friend of Cézanne and Van Gogh, who treated him for his mental illness.

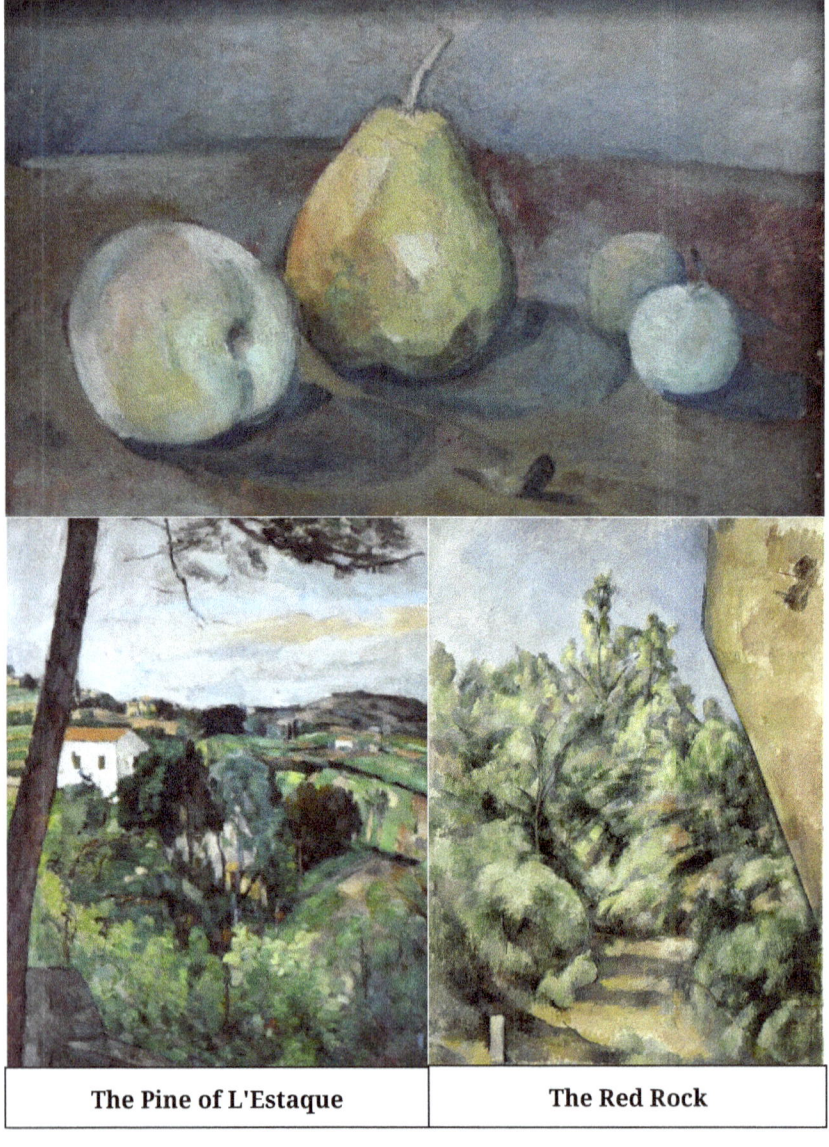

| The Pine of L'Estaque | The Red Rock |

The Pine of Estaque
This is one of Pisarro's most influential works.
The inclination of the trunk on the left draws the viewer's attention to the center of the painting: the little white house and the three trees.

The Red Rock
It is one of his masterpieces and most audacious. It was acquired by Juliette, Guillaume's widow.
The imbalance or asymmetry of the composition is created by the rock on the right side of the painting, inclined and shaped like a sarcophagus that seems to fall onto the thick forest of the background. The perspective appears very blurred.

Portrait of the artist's son
The painter's son is portrayed here sitting in an armchair of which we can only see the backrest. The simplicity of the figure and the reinforcement of the contour stand out, something typical of Paul Gauguin.

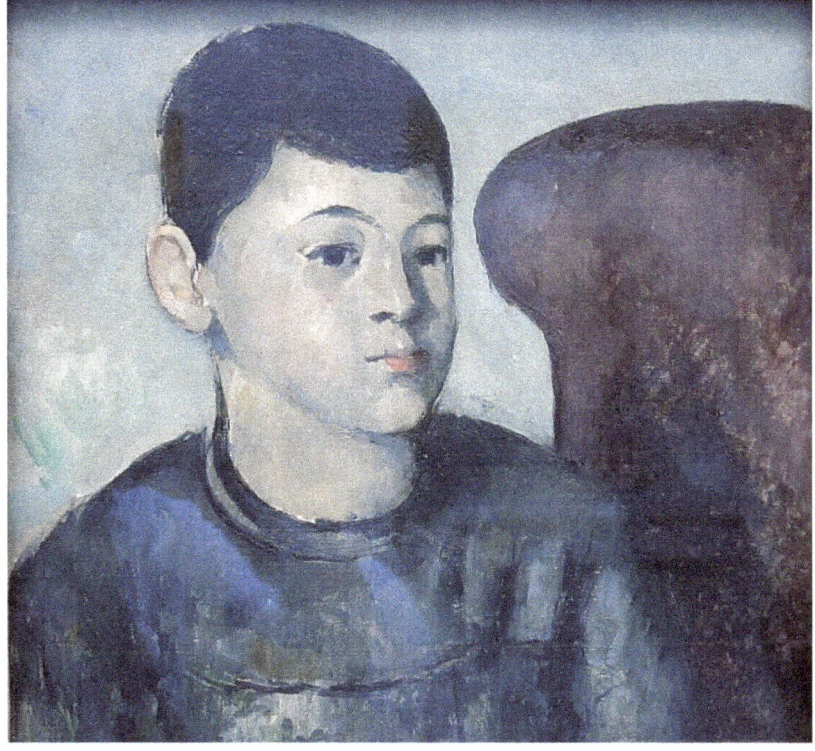

The Boat and the Bathers
(La Barque et les Baigneurs)
This painting was commissioned to decorate a mansion of a rich businessman. It was divided into 3 parts, two of which were owned by Paul Guillaume's widow. The French State was able to acquire the third part and reconstructed the work.

The painting is very long and has two groups of bathers, one on each side, separated by the sea and some boats.

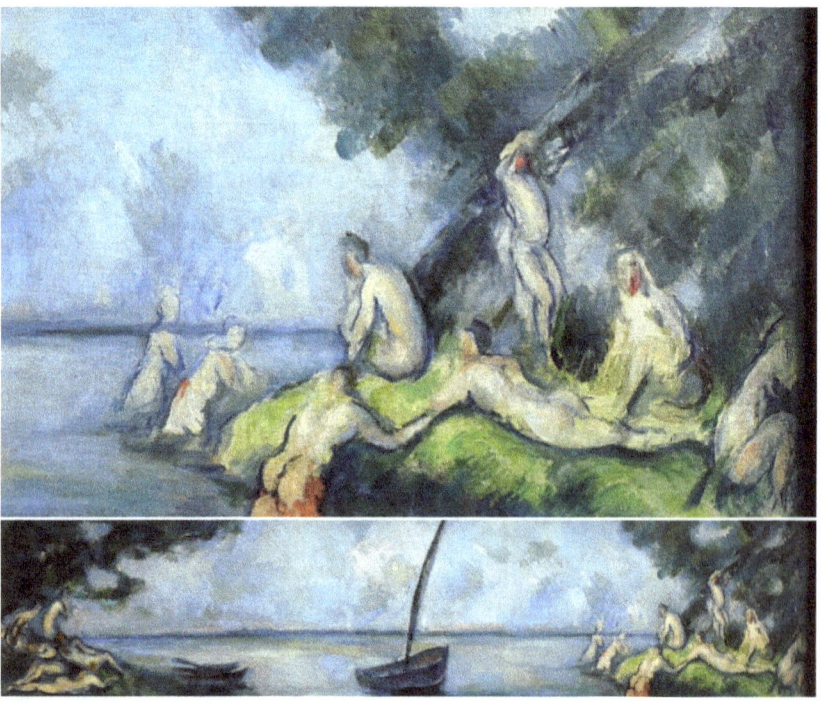

The Luncheon on the Grass
(Le Déjeuner sur l'herbe)
It is believed that Cezanne named the painting that as a tribute to Monet, whose work, with the same title, was strongly rejected by academic art. The thick brush strokes that draw very simple shapes stand out.

L'ORANGERIE GUIDE

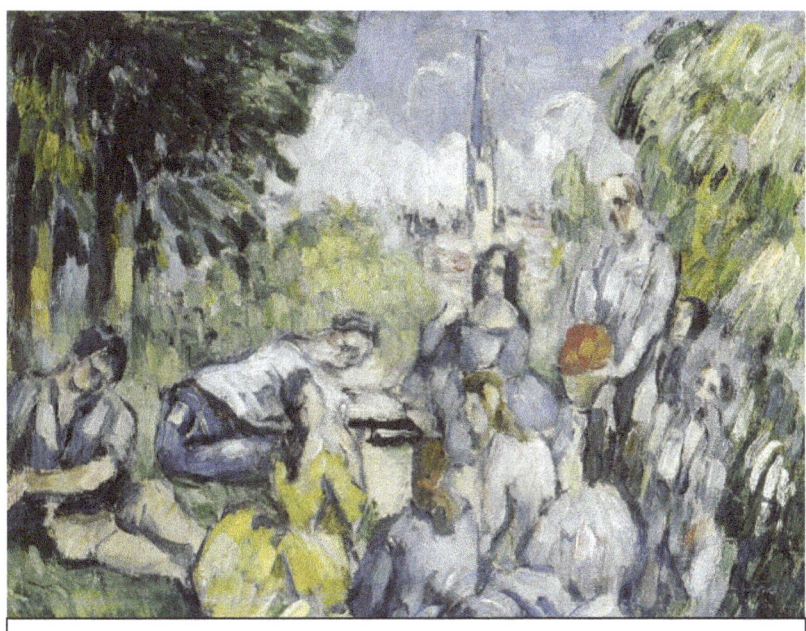

Luncheon on the Grass

In the grounds of Château Noir (Dans le parc de Château Noir)

Portrait of Madame Cézanne

Madame Cézanne is represented as rigid and with a severe and expressionless face.

His technique is characterized by loose brush strokes and by leaving parts of the white canvas unpainted, in order to achieve light colors. Cézanne always worked quickly, although he left it unfinished on purpose, since the painter hated finishing his works, for the

unfinished. It's the perfect thing.

Madame Cézanne in the garden

The figure of Madame Cézanne is represented with solemnity, and her expressionless face gives her a certain grandeur.
It has large unpainted areas around the figure, where the white canvas is visible. He left the bottom of the dress and the feet unfinished.

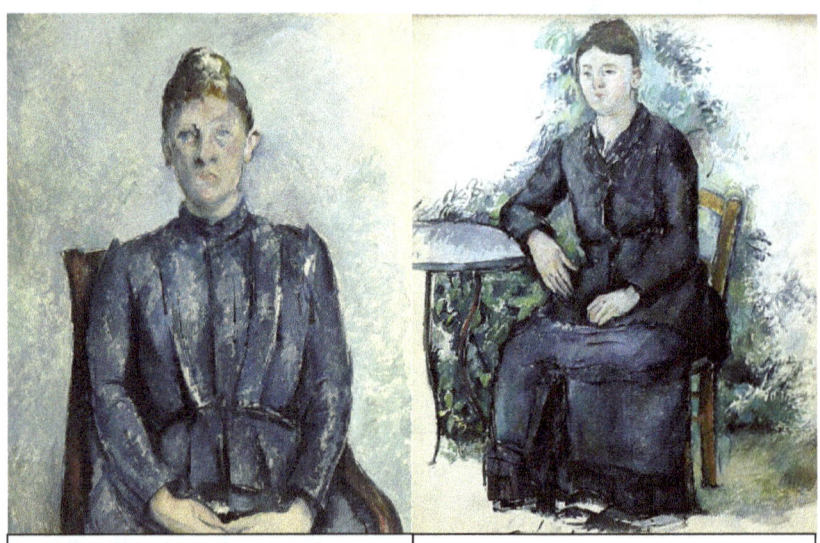

| Portrait of Madame Cézanne | Madame Cézanne in the garden |

RENOIR

Son of a seamstress and a tailor. He had 6 brothers. He is the most sensual impressionist painter, who shows the search for pleasure and happiness, the most pleasant aspect of life and nature, following the tradition of the painters of the century XVIII.

He said that the purpose of a painting is to decorate a wall, so it is important that it be pleasant in itself.

L'ORANGERIE GUIDE

He is the painter of the female nude, reminiscent of the thick forms of Rubens.
His painting is influenced by Delacroix, Corot, Manet and Degas.
He was a great friend of Monet with whom he painted some works.
In the Orsay Museum we can see its emblematic Ball at the Moulin de la Galette, and the great bathers.

He uses intense colors and bright light. The details are created with soft brush strokes. The human figure is the center of his work.

At the first Impressionist exhibition in 1874, Degas invited Manet, who excused himself by saying that he would never exhibit with Paul Cézanne, but Renoir thought that Manet did not accept because he did not consider himself an impressionist.
Renoir exhibited 6 paintings for which he used an actress as a model.

-In 1876 he painted Dance at Le Moulin de la Galette, his best-known work, in which he represented an open-air dance in Montmartre.
-His first stage is typically impressionistic, in the use of quick brushstrokes, intense colors and bright light.
-In 1883, after his trip to Italy, where he discovered Raphael and Leonardo da Vinci, a return to classicism can be seen, with more precise lines that highlight the contours of the female figures (the blonde bather). At this stage, Renoir enters a deep depression in which he feels that he does not know how to paint or draw, destroying many works. His friend, the painter Ingres, helped him.
-After 1890 he blurred the contours again, and painted more and more female nudes and scenes of daily life (girls at the piano).
He is the impressionist painter with the largest number of works exhibited in this museum.

The female figure represented in everyday life situations is full of sensuality and inspired by the baroque style of Rubens.

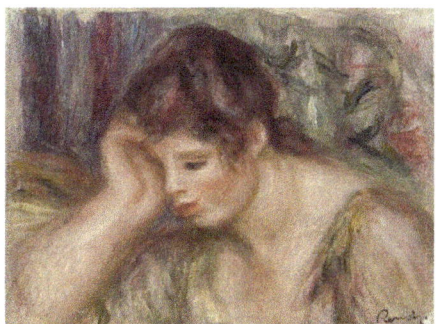

Woman leaning on her elbows (Femme accoudée)
This painting was a part of a larger one. The robust figure of the woman rests her head on her hand.
Her arm and neck are very large and disproportionate.
In the background, on the right, we can see some flowers.

Woman with a Hat
(Femme au Chapeau)
Painted at the end of his life. It stands out for its light tones, quick brush strokes and showing areas of the white canvas, which also gives the impression that the painting is unfinished.

Blonde Girl with a Rose
(Blonde à la rose)
We can see Madeleine Heuschling, wife of Renoir's son.
The use of red colors stands out. In some parts the brushstrokes are thick, while in others they are soft, and you can even see the white canvas.

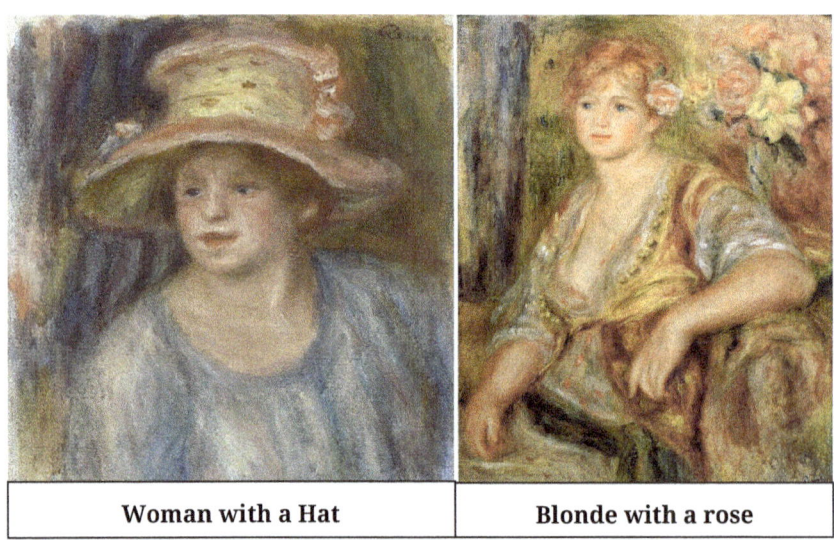

| Woman with a Hat | Blonde with a rose |

Nude woman in a Landscape
(Femme nue dans un paysage)
Here he portrays the model and painter Suzanne Valadon.
The painting marks the beginning of a change in style and a criticism of himself. After visiting Rome and learning about the work of the great painters of the Renaissance, he judged that he did not know how to paint and that he should abandon Impressionism.

Although it maintains the impressionist style in the background, the female figure is treated with more firmness and detail.

Seated Bather drying her leg
(Baigneuse assise s'essuyant une jambe)
It belongs to its final stage. It alternates very thick brushstrokes with soft ones. This mixture of brushstrokes in the background of the painting is worth highlighting.

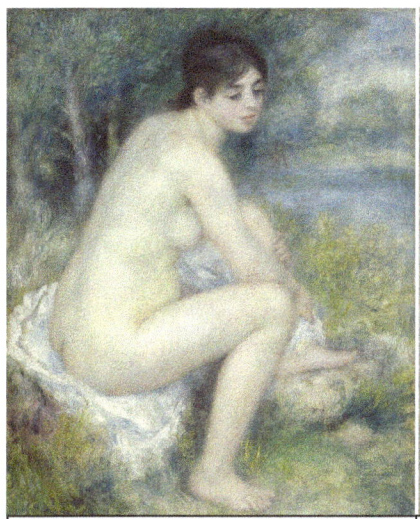
Nude woman in a landscape

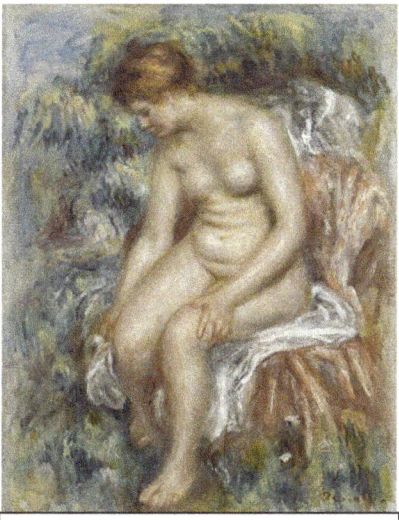
Seated bather wiping her leg

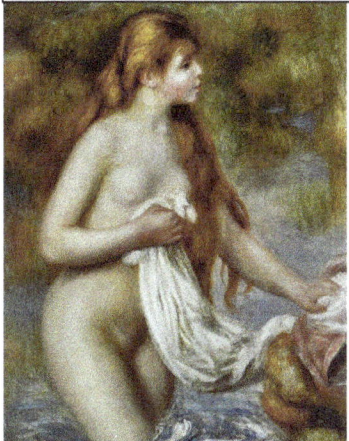

Bather with long hair
(Baigneuse aux cheveux longs)
This composition is full of dynamism: the movement of the body, its rounded shape, the folds of the towel, and the force of the river current.
The colors are warm.

Nude woman lying down
(Femme nue couchée)
In this painting, Renoir portrays Gabrielle, who was the family nanny, and a relative of Madame Renoir. She is the model that appears in the largest number of the painter's paintings.

The influences of the great classical painters are clear. The light colors and the strength of the light in the figure and the sheet stand out, which contrast with the darker background.

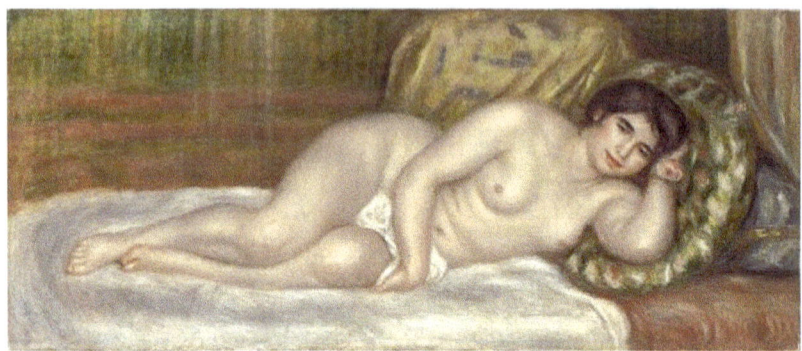

Claude Renoir as a clown
It is one of the few occasions where his son posed for Renoir, and whom the painter had to convince by promising him some toys.
It represents him with a noble and grandiose bearing. This portrait has influences from the great Baroque painters.

Gabrielle in the garden
The figure of Gabrielle appears in a garden, surrounded by light and with her face dazzled by the sun. It is characterized by delicate brush strokes.

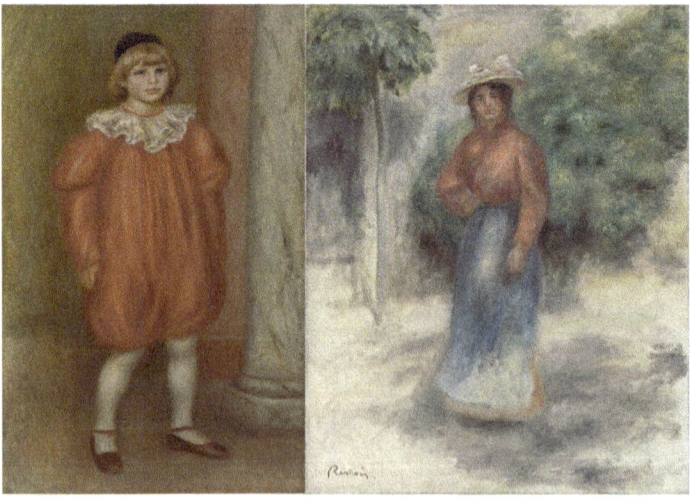

Claude Renoir, playing
(Claude Renoir, jouant)
The painter's son appears playing with tin soldiers. The thick and rough brushstrokes in the background that surround the figure of the child, made in great detail, stand out.

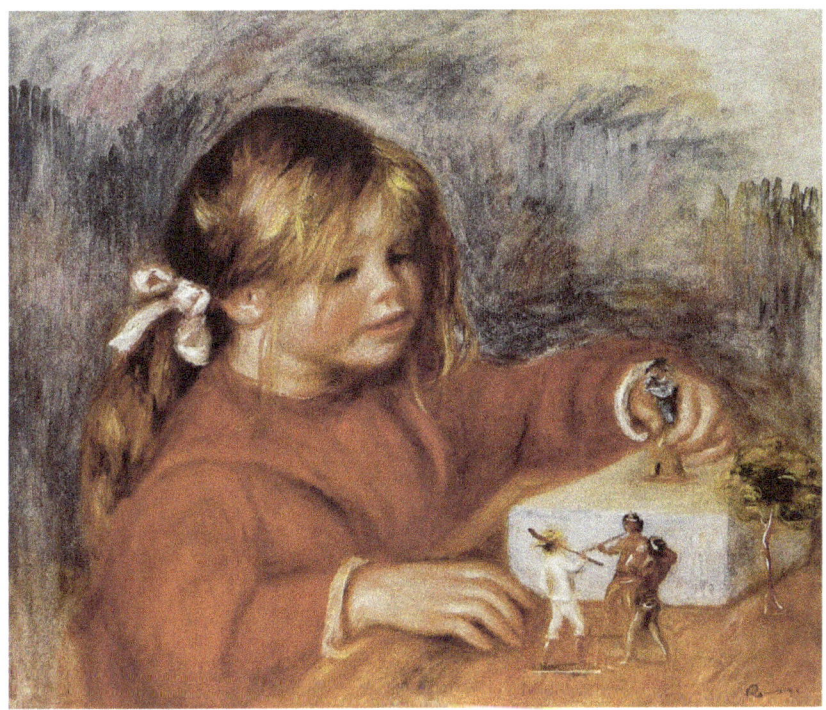

Gabrielle Renard and Infant son, Jean
The painter's son and his nanny play with some chicks, which are barely outlined. The figures blend in with the table and the flower tapestry in the background.

Young girls on the piano
This was the first Renoir painting acquired by a French museum. Warm, diffused colors surround the figures of the two young women at the piano, treated with great detail and a fine brushstroke, for example, on the back of the chair.

L'ORANGERIE GUIDE

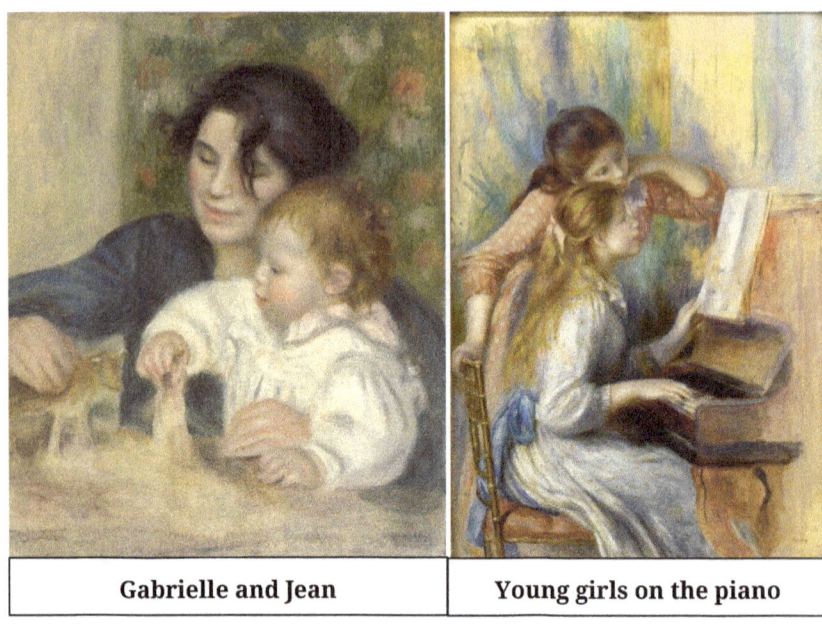

| Gabrielle and Jean | Young girls on the piano |

Yvonne and Christine Lerolle at the piano
(Yvonne and Christine Lerolle au piano)
The figures of the women are defined in great detail.

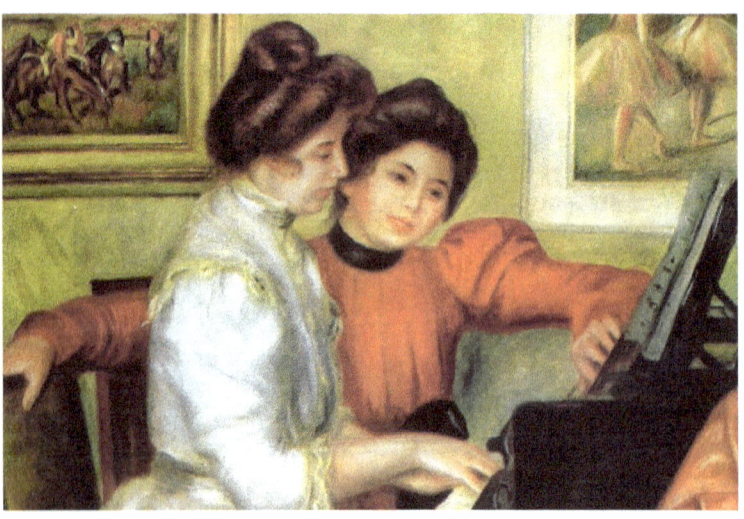

The white of the dresses and the yellow background convey a cold atmosphere. On the back wall you can see two paintings by Degas.

Portrait of two little girls
(Portrait de Deux fillettes)
The fine, soft brushstrokes and chromatic harmony stand out, uniting the two figures with the background. The face of the girl with the hat, with her large eyes, is treated with a very fine brushstroke.

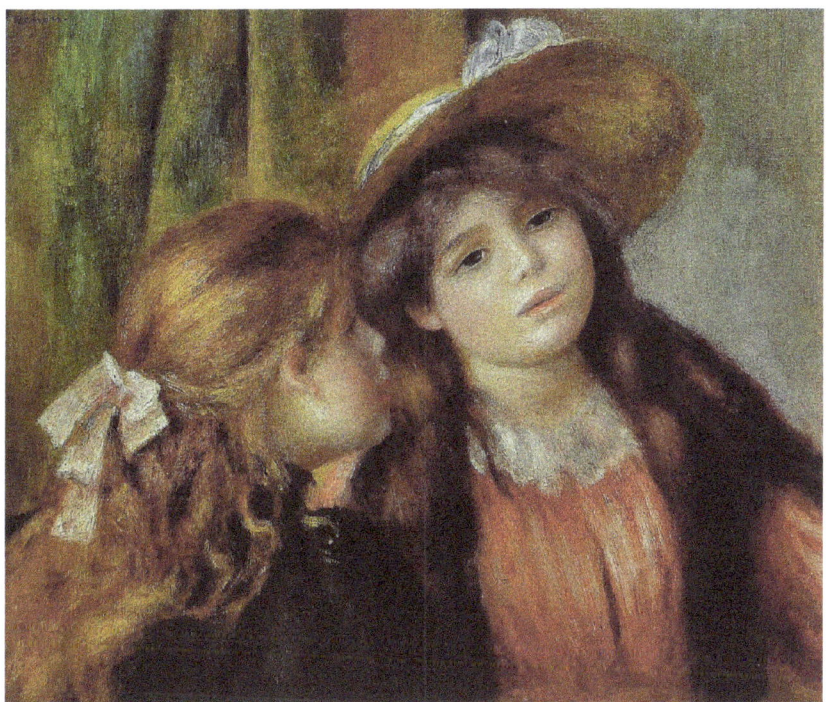

Woman with a Letter
(Femme à la lettre)
The rigid figure of the woman, with her black eyeballs, gives her a cold and ghostly appearance. She holds a letter in her hand and seems to reflect on its contents. The dress is white and blue, as is the bluish, hazy background. timeless.

Portrait of a young man and a young girl
Portrait of a friend of the painter with a young woman. It highlights the

strength and vividness of the colors used harmoniously. The luminous background surrounds the couple, which seems to transmit a shared feeling that remains frozen in time.

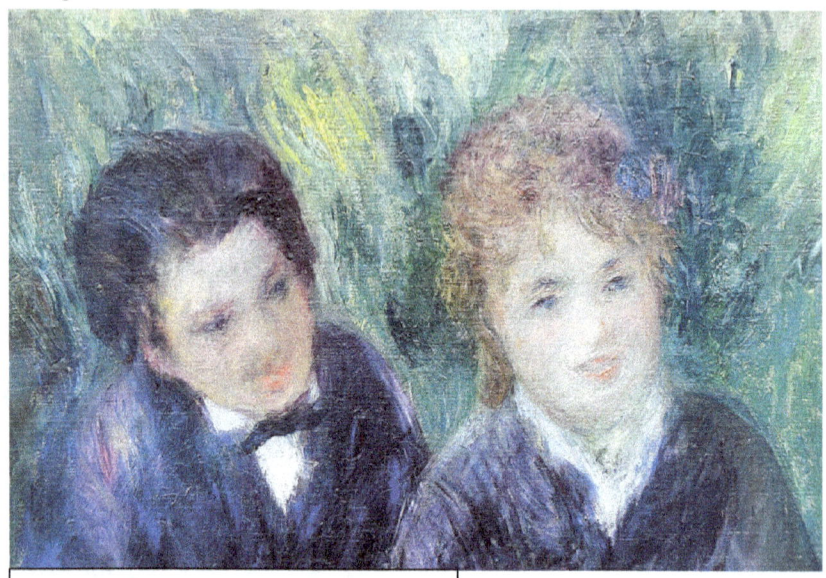

Woman with a Letter

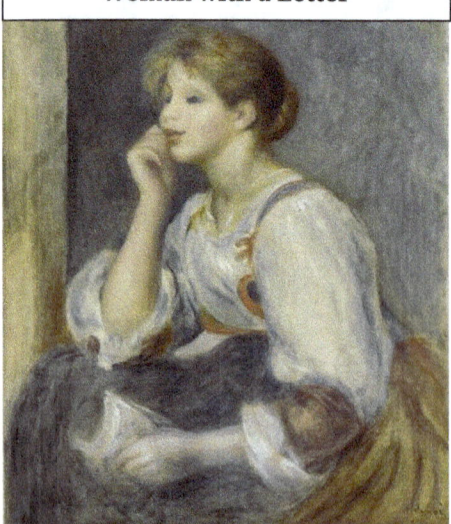

Flowers in a vase
Careful composition of different floral species, with yellow, green and red tones, on a white background, which makes the bouquet stand out more. It is worth highlighting the white reflections in the center of the vase.

Bouquet
Bouquet of roses and poppies in a green vase. Cezanne's wife made various floral compositions that were painted by the author. Their intense and vivid colors stand out, which stand out even more against the blue background.

L'ORANGERIE GUIDE

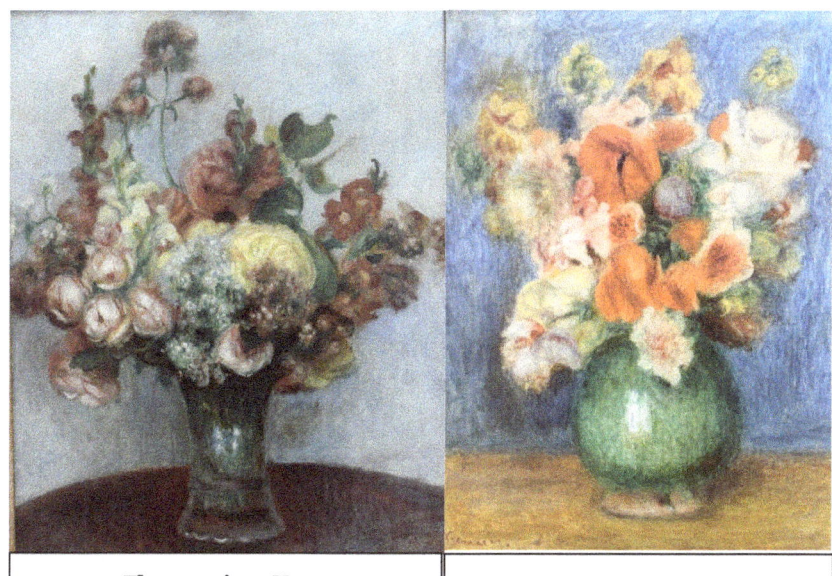

| Flowers in a Vase | Bouquet |

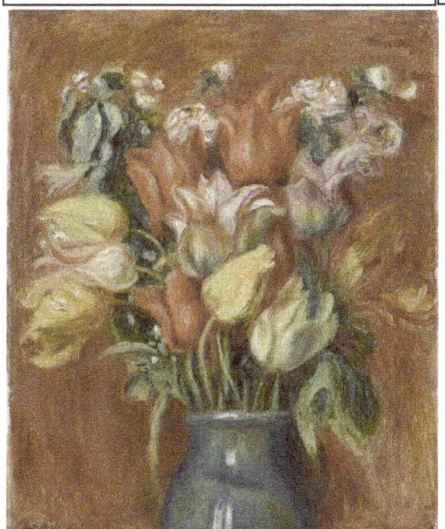

Tulip bouquet
The painter admired flowers, which he considered the most majestic in nature.

On a background with red tones we can see tulips of red, yellow and green colors.

The thick brushstroke stands out.

Bouquet in a box
Composition where the contrast between black and white stands out, as well as the lack of depth.

The bouquet is wrapped in paper and resting on a chair.

L'ORANGERIE GUIDE

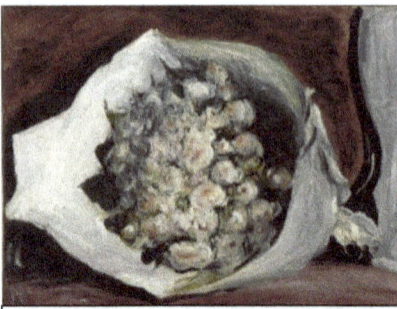
Bouquet in a box

Strawberries
(Fraises)
The strawberries are piled up in a fruit bowl next to a sugar bowl and some lemons.
The colors are bright and intense: reds, yellows and blues on a white tablecloth. The lemon that is being cut and the folds of the tablecloth highlight the vividness of this composition full of strength.

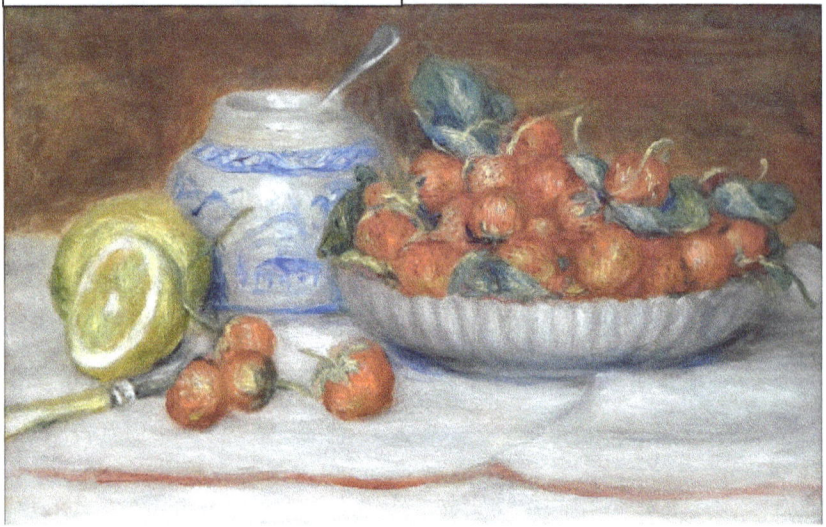

Apples and pears
(Pommes et poires)
The fruit bowl seems to float on the tablecloth, at the mercy of the waves, represented by the white folds. Pears and apples are confused. The composition is endowed with great strength and liveliness.

Peaches
(Pêches)
The composition is treated in different planes: frontal and profile. The apparent static nature of the pile of fruits is broken by the peach on the

left, which has fallen from the fruit bowl.
The tablecloth and white fruit bowl contrast with the fruits and the background.
The thick, strong and undulating brushstrokes give life to the background.

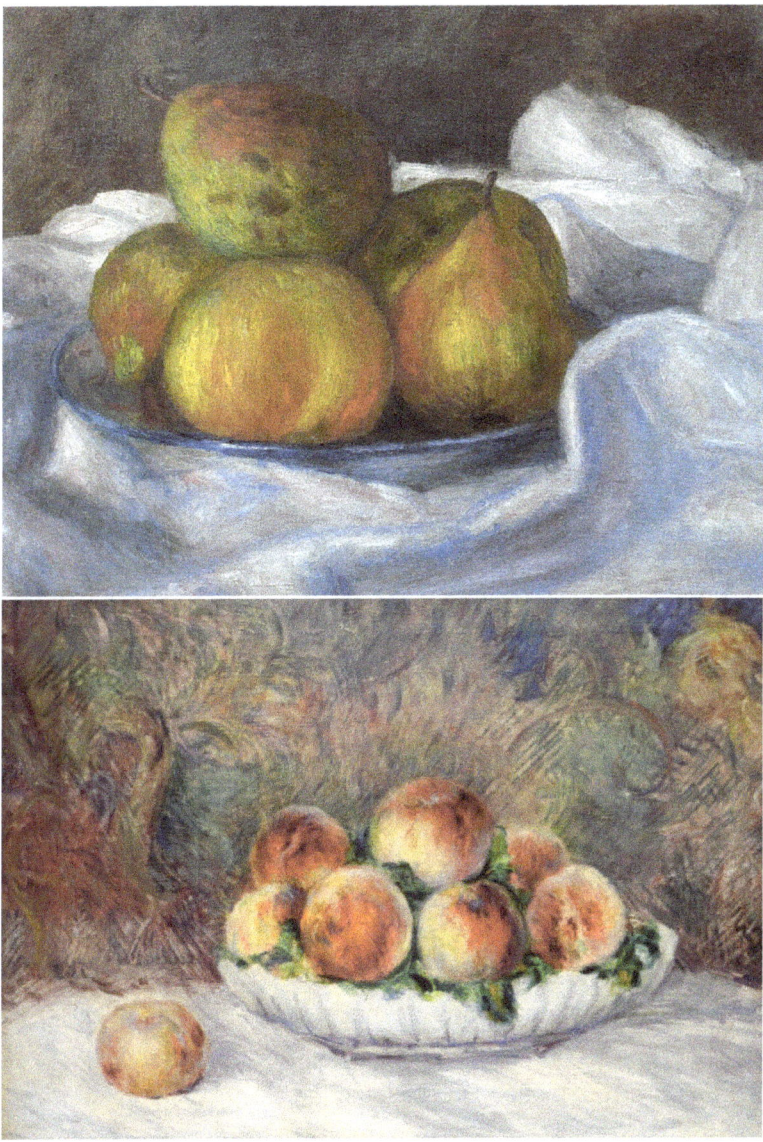

Snow landscape
(Neige Paysage)
It is one of the few landscapes that Renoir created, since he always declared that he hated winter and the cold, and when he could he went to live on the shores of the Mediterranean.
In the foreground, snow appears blurred in the colors of the vegetation and rocks. In the background, some delicate trees seem to bow to the power of the cold winter.

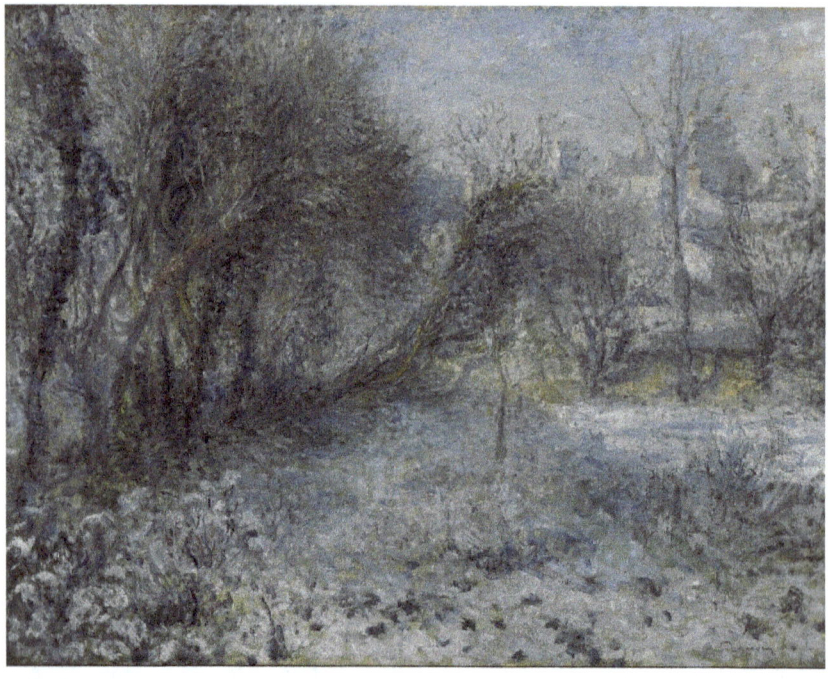

ALFRED SISLEY (1839 - 1899)
(Light in the landscape or the purest impressionist)
Painter in the impressionist style, with an introverted temperament, son of English merchants who lived in France.
While studying painting in Paris, he met Monet, Renoir and Bazille, with whom he painted outdoors around Paris.
After being disinherited by his father, he lives with a young woman. The couple is portrayed by Renoir in his painting: Les Fiancés (The House of

Sisley).
Years later he met Manet, and the famous journalist Émile Zola, when he frequented the Café Guerbois.
In 1871 he left Paris to take up residence in Louveciennes, near Renoir's house, where he painted the Marly-le-Roi forest and the banks of the Seine River.

Monet introduces him to the collector Durand-Ruel who buys most of his works and offers to exhibit his paintings in his gallery in New York.
He also participated in the exhibitions of impressionist artists organized in Paris, and even joined the Fine Arts society. During his life he went through some economic difficulties. He was recognized 1 year after his death, and was considered the best landscape painter.
As a curiosity, the impressionist painter who best painted the shores del Sena was never able to obtain French nationality due to a bureaucratic problem.

Your style

Sisley was the landscape painter par excellence, among the impressionists.
Its landscapes transmit a feeling of calm and serenity.
It is characterized by the delicate brushstroke and the softness of the colors.
His snowy or misty landscapes, with yellow, pink and blue reflections, are influenced by Gustave Courbet and Camille Corot, as well as by oriental art.
The use of light, the infinite skies, water and other meteorological elements are similar to those of Monet, whose influence is very noticeable, but it differs from him in that Sisley always gives primacy to form.
•The breadth of the sky serves to give depth to his paintings.
The figures are silhouettes, barely sketched, the main element is always the landscape itself, in which the light arranges all the elements in harmony.
-In its initial stage it uses the darker colors, greens and browns.
-At maturity the colors lighten and soften.

-In a later phase, he began with his series of paintings, which represent the same object at different times or times of the year.
the same theme in different periods (for example, the paths of the Sablons).
-At the end of its life, the impressive cliffs hit by the waves stand out, where we can see the effects of light on the water and sand.

Le Chemin de Montbuisson à Louveciennes (1875).
Landscape of the Seine river located west of Paris. A path, in the foreground, takes the viewer to the river. In the background, a huge cloudy sky.

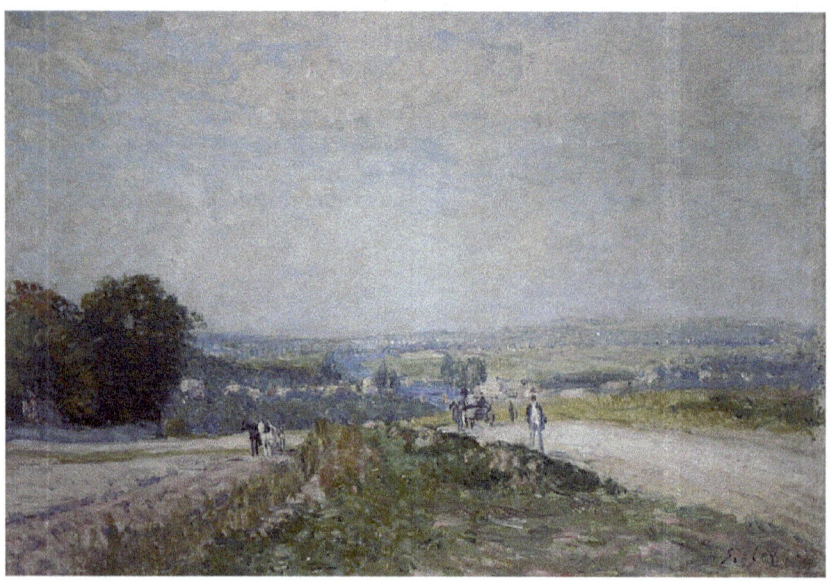

HENRY ROUSSEAU
(Level -2, Room 8 Arts in Paris)
He is included in post-impressionism. A self-taught painter, who said that he had nature as his only teacher, he was the creator of Naive art.

He was derogatorily called the customs officer for his work in the river port of Paris. When he retired he dedicated himself to playing the violin in the streets.
Its beginnings in realism are soon overtaken by surreal, naïve and apparently childish, exotic, and even cartoonish elements, in what is the

creation of new naïve art, difficult to fit into any style.
The deficiency of his pictorial technique is overcome by the sensitivity he transmits and is expressed by his particular use of color.
The painter who never traveled outside of France became famous for depicting jungles and beasts that he could only see in illustrations in books and in natural history museums.
He said that the strange plants in the greenhouses of the botanical garden made him fall into a dream.
He also painted some landscapes of the city of Paris.

In his landscapes there is a lack of perspective, and on the same plane he superimposes one or several flat, rigid and expressionless figures that look towards the viewer with their large open eyes. The light does not reinforce the outline of the figure nor does it give depth, so The result seems somewhat artificial and unreal.

He always began by painting the landscape, and when it was finished, he added or superimposed human or animal figures, and finally, he repainted some areas.

The Cliff
(The falaise)
We can see a cliff on the coast of Normandy made with its characteristic simplicity of features. We know that the painter did not know the sea, since he barely left Paris and recreated his memory from the works of other painters such as Courbet, or perhaps, in some photographs of the time.

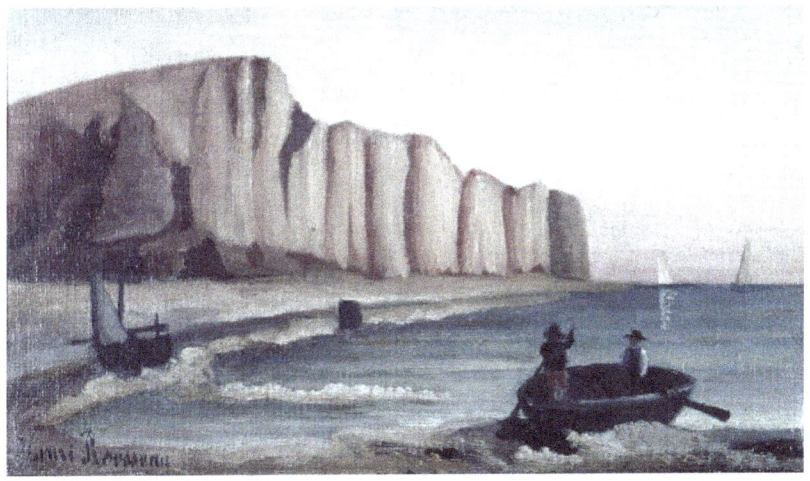

The Ship in the Storm
(Le Navire dans la tempête)
Rousseau longed to travel, but at the same time, he feared the dangers of travel, which take us into unknown forces that we cannot control. The leaden rain looks like a metal plate that is going to inevitably hit against the toy boat. The waves rise threateningly and surround the boat like a big mouth.

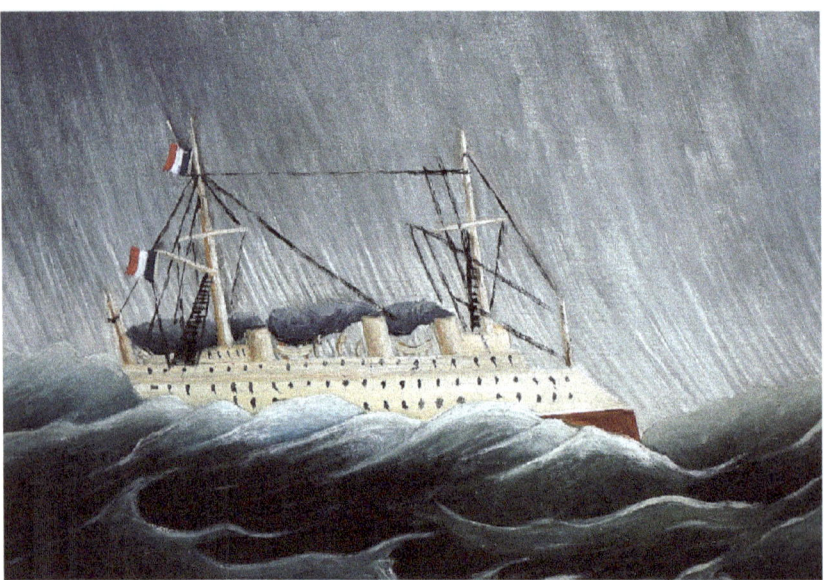

Fishermen
(Les Pêcheurs à la ligne)
A scene of rural life broken by incipient progress and industrialization. The figures of the fishermen with their rods contrast with the modernity of the plane that flies over the skies of France. What takes them out of the routine of their work for a moment, forcing them to look at the sky.

The Carriage of Father Junier
(The Carriole du Père Junier)
This painting served the painter to pay a debt to Mr. Pere Junier, a gardener in the area.
The seriousness and rigidity of the figures that are on the car, with their

frontal gaze, including that of the dog, give the sensation of being in front of dolls or marionettes.

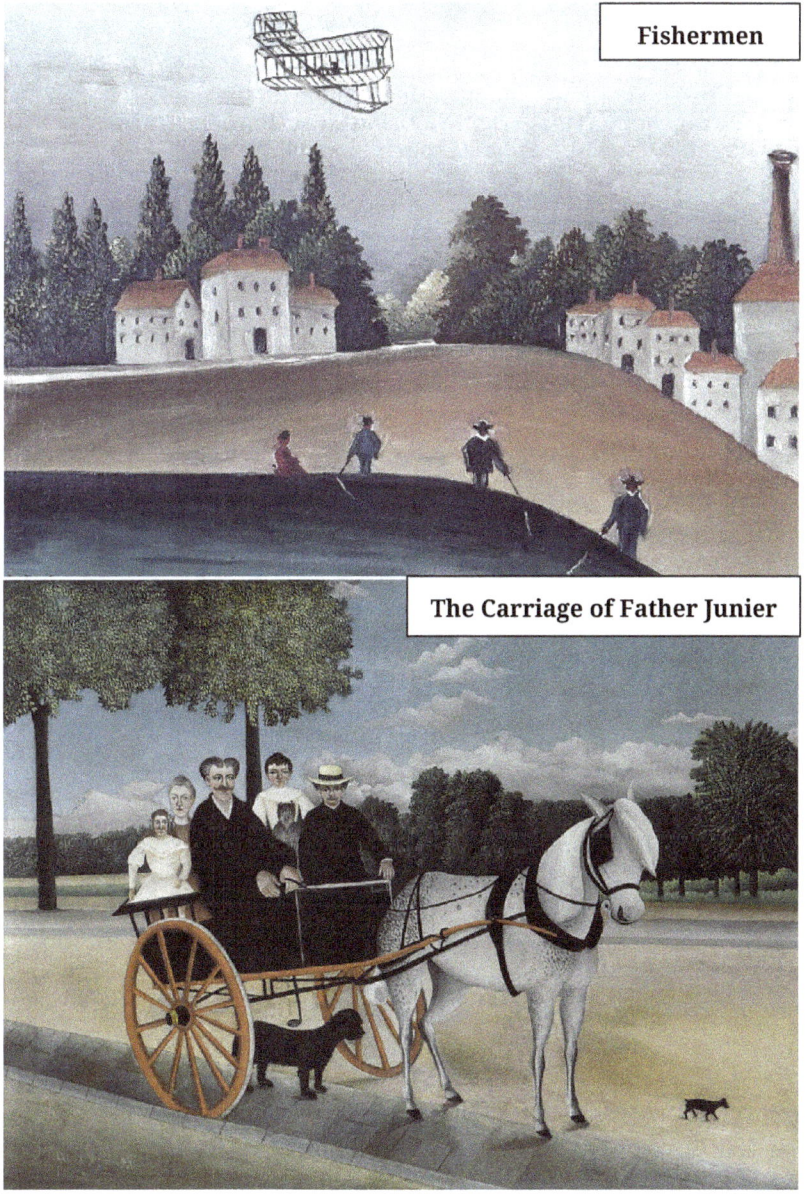

Fishermen

The Carriage of Father Junier

The Wedding
(La Noce)
In this portrait of a family wedding, it is striking that the bride is levitating, without having her feet resting on the ground. In the background, a deep blue sky and some small, exotic-looking trees surround the group. In the foreground a large dog appears and looks at the viewer.
The whole appears to us as something unreal.

The Child with the Doll
(L'Enfant à la poupée)
The strange boy stares at the viewer. His figure lacks depth and looks like a paper doll.
It has a disproportionate size. Small arms and large legs that sink into the grass and are painted in profile, which causes a strange sensation. The color of the grass and the blue sky create perspective in the composition.

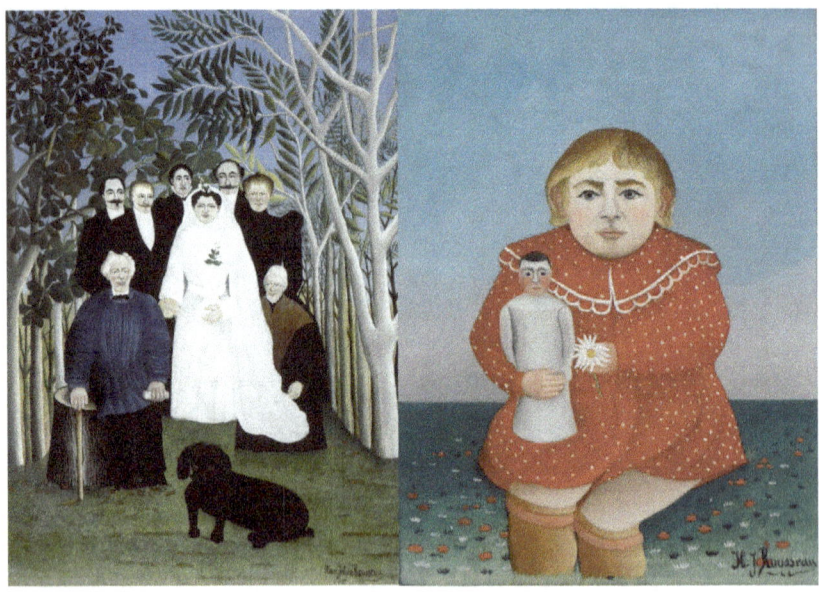

The Chair Factory in Alfortville
It is very bold for the time to paint a boring industrial landscape.

The immense building with gigantic doors and windows contrasts with the smallness of the walkers and the fisherman.
The road is too narrow and its curves oppose the straight lines of the buildings.

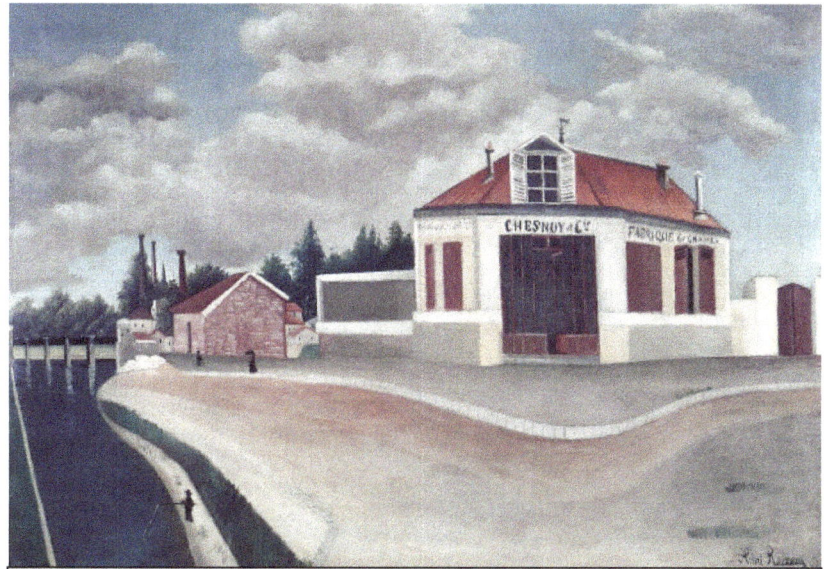

The Chair Factory in Alfortville
(La Fabrique de chaises à Alfortville)

GAUGUIN

Post-impressionist painter. Son of a journalist and a prominent feminist leader, originally from Peru, where the painter spent his childhood. He was fond of boxing and fencing, and dressed extravagantly.
She began painting with Pissarro and strongly admired Degas, with whom she always had a strong friendship.
Gauguin rejected Seurat's pointillist technique.

Its purpose was to capture the soul of what it represented (nature, landscapes, people), purity, harmony, serenity, unraveling the spirituality of everything that surrounds us in daily life.

Most of his techniques were considered experimental.

Egyptian elements appear in two works: His Name is Vairamauti and Ta Matete.

In 1886 he began to paint landscapes where nature and the use of pure colors become the protagonists of the painting, and the forms are subordinated to them, an example is:
The Breton Shepherdess, the young Bretons bathing and the Four Breton Women, with elements that are close to caricature.

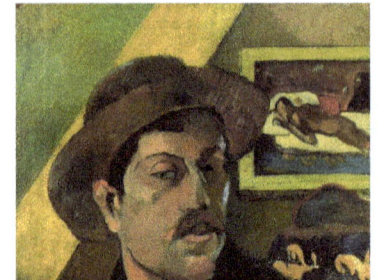

Influenced by oriental art, he eliminates all perspective and color gradations, paints the shapes with pure colors and highlights their contours with black colors.
Years later, color and shape come to have an equivalent value, which is called synthetic style.
It is known that 3 of these works were purchased by Van Gogh's brother.

Van Gogh deeply admired Gauguin, they painted together in the yellow house that Van Gogh had in Arles. They were great friends, until the relationship was abruptly broken when on December 23, 1888, Van Gogh attacked him with a razor, and then cut off his left ear.
Gauguin left Arles and they never saw each other again.

Claude Schuffenecker was a French Post-Impressionist painter and acquired Vincent van Gogh's first painting. Schuffenecker was a great friend of Gauguin.
Degas bought Gauguin's melancholy (Te faaturuma), woman with mango and Olympia, and presented it to an exhibition where painters such as Pisarro, Monet and Renoir criticized and mocked his works.
For his help, Gauguin gave Degas his work The Moon and the Earth.
The painting Riders on the Beach is strongly influenced by Degas's Hippodrome before the Race.

When Gauguin resides in Tahiti, he supports the natives against the false accusation of a gendarme, which results in him being sentenced to prison for 3 months, which he never served, as he died suddenly of a heart attack.
Gauguin is considered the initiator of primitivism, which is based on simplicity, departs from the classic proportions of the human body, represents the wildest nature and uses animal figures and geometric designs.
His style was greatly admired by Van Gogh, Matisse and Pablo Picasso.

He once said that art derives from nature, it is an abstraction that focuses on the act of creation itself and not on the result, which is why for Gauguin, it is a mistake to copy nature as it is.

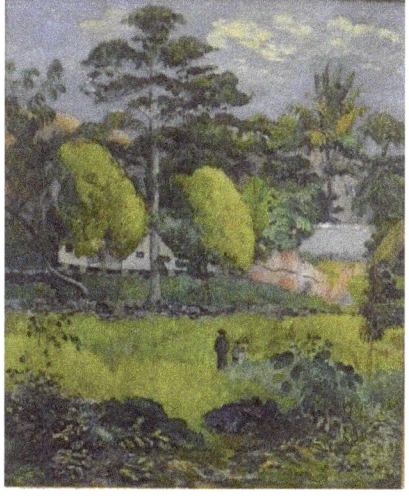

Landscape (Paysage)

This work represents a landscape of French Polynesia, where the painter lived. In the background, a lagoon and a white cabin appear, almost covered in vegetation of various green tones.

In the central part we can see a group of children with a missionary. It was painted two years before Gauguin's death.

The superimposition of the figures breaks the depth of the painting.

AMADEO MODIGLIANI
(Level -1, room 3)

Italian painter and sculptor of Jewish origin whose portraits and nudes are among the most sought-after in the world, making him one of the greatest artists of the 20th century.
He always lived in poverty, although he tried to pretend otherwise, saying that he came from a family of bankers.
He traveled to Venice to learn painting. There he began a life of debauchery.
In Paris he met Pablo Picasso and Chaïm Soutine, as well as the poet Apollinaire. When he met Constantin Brâncuși he began to create his sculptural work, which had a primitivist idealism, with an exaggerated elongation of human figures.

His stormy love life prevents him from having a stable relationship, until he meets the young Jeanne Hébuterne, barely 18 years old, whom he never married.

Many of his partners pose as models for his paintings as we can see in: Madame Pompadour and Maria Vassilieff.
His nude paintings are removed from art galleries, which exacerbates his chronic alcoholism.
He died in 1920 at the age of 35 as a result of tuberculosis contracted in his youth, after remaining in bed for several days in a lamentable state of abandonment and physical deterioration.

On the same day of his funeral, 20 of his paintings are exhibited for the first time. A few days after Modigliani's death, Jeanne Hébuterne, pregnant with the painter, commits suicide. A year later, Jeanne's mother agrees that her daughter's body be buried next to Modigliani's.

His work is influenced by Cézanne and Toulouse-Lautrec, as well as the cubism of Picasso.
His own style cannot be included in any of the artistic trends of the time. It is characterized by linear layout and rapid execution, since he never retouched any of his paintings. He had a prodigious ability to portray the interior of people.
He painted Picasso and Soutine.

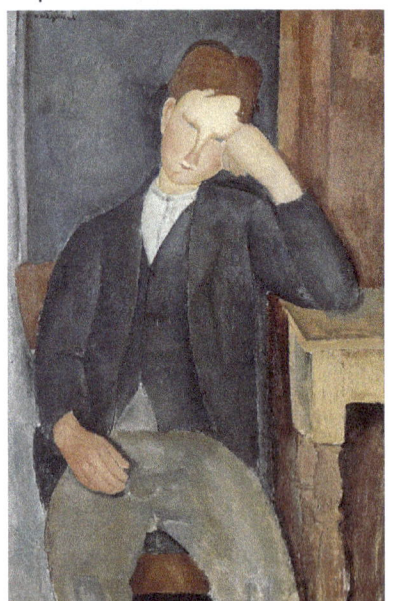

The Young Apprentice
This work has influences from Cézanne and Gauguin.
We can see the figure of a thoughtful young man, with the appearance of a heavy sculpture and rough hands. The contours are outlined. The depth is missing.

Red-haired girl
(Fille rousse)
This painting of a young woman with an elongated face has influences from the cubist style. In the background you can see simple geometric shapes of different soft tones.

Woman with Velvet Ribbon
(Femme au ruban de velours)
This elongated face, with its empty eyes, is influenced by African and Polynesian art.
In the dark background a landscape appears. The brushstroke does not cover the entire painting, revealing the white canvas.

L'ORANGERIE GUIDE

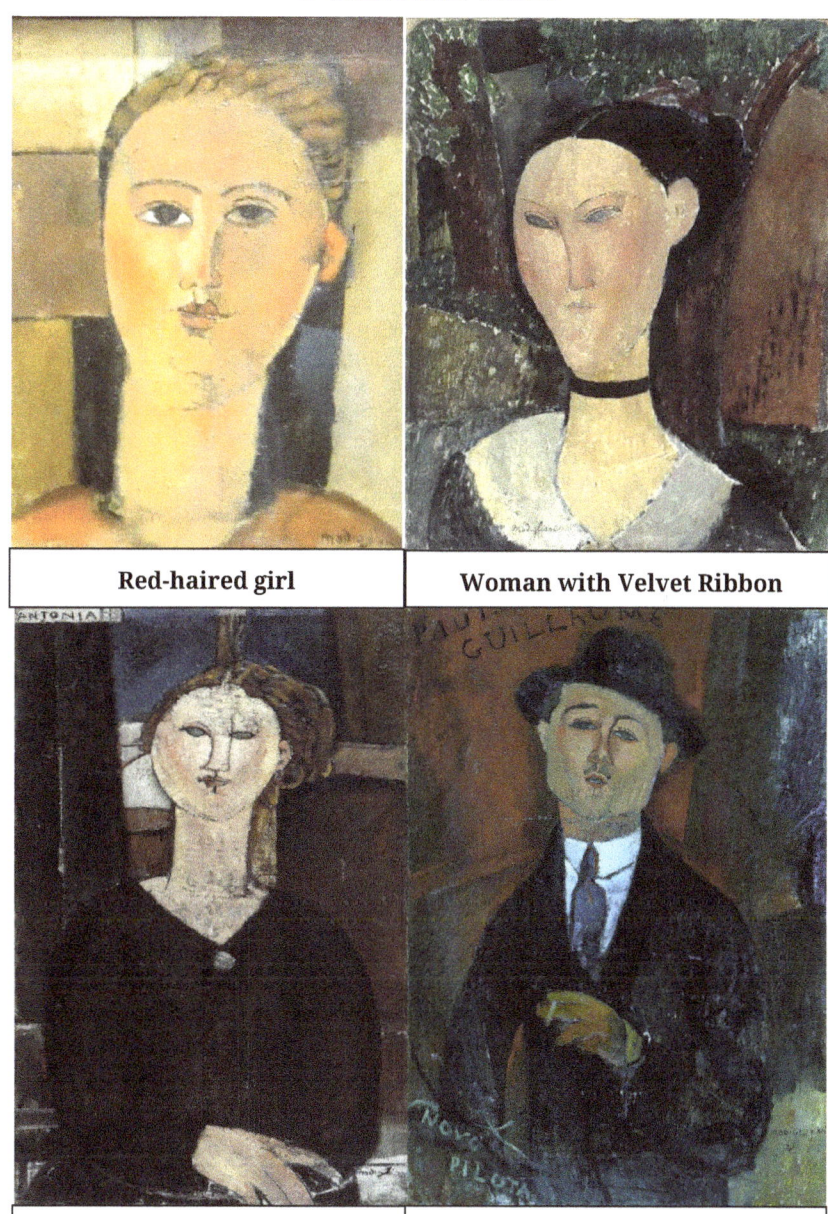

Red-haired girl	Woman with Velvet Ribbon
Antonia	Paul Guillaume (Novo Pilota)

L'ORANGERIE GUIDE

Antonia
Work of cubist influences. The woman has a rounded face, long neck and large hands. The frontal face contrasts with the ears and hair on the right, which appear in profile.
The background has the geometric shape of a cross. The figure also has his arms crossed. Next to his name, a small cross is painted.

Paul Guillaume (Novo Pilota)
(Level -2, Room 8 Les Arts à Paris)
Paul Guillaume financially supported Modigliani, who made several portraits of his patron, a lover of new artistic trends.
In this painting Paul Guillaume is barely 23 years old. He appears with a certain haughty air and a penetrating gaze.
His square-shaped face is painted in a very light tone, which contrasts with the dark background, and makes the viewer focus on him.

CHAIM SOUTINE
(Level -2, Room 9)

Belarusian painter who was part of the Paris School.

His father, who was an Orthodox Jew, refused to let his son learn to paint. Despite this, Soutine entered the School of Fine Arts and later arrived in Paris where he met Modigliani, whom he painted on several occasions.
In 1927 he held his first exhibition and entered the circle of so-called independent artists. During the Second World War he was forced to leave Paris and his health problems worsened, dying shortly after in a hospital.

His expressionist style is influenced by Rembrandt, Cézanne and Van Gogh. He had a very peculiar way of painting. He did it at such an accelerated pace that it seemed like he was suffering from a fit of madness.
I always needed to paint with a model in front of me.

The White House
(Le Maison Blanche)
This landscape is unusual in Soutine due to its greater realism. In the foreground, two roads that join into one that turns to the left, creating

depth to the landscape. In the central area, a house with straight lines that resists the blow of the trees that wriggle.

Landscape
(Paysage)
This landscape is endowed with life and haunts Soutine's fears. In the background a large tree leans towards the viewer's right. The blue sky moves in the same direction.
The colors are lighter and more intense.

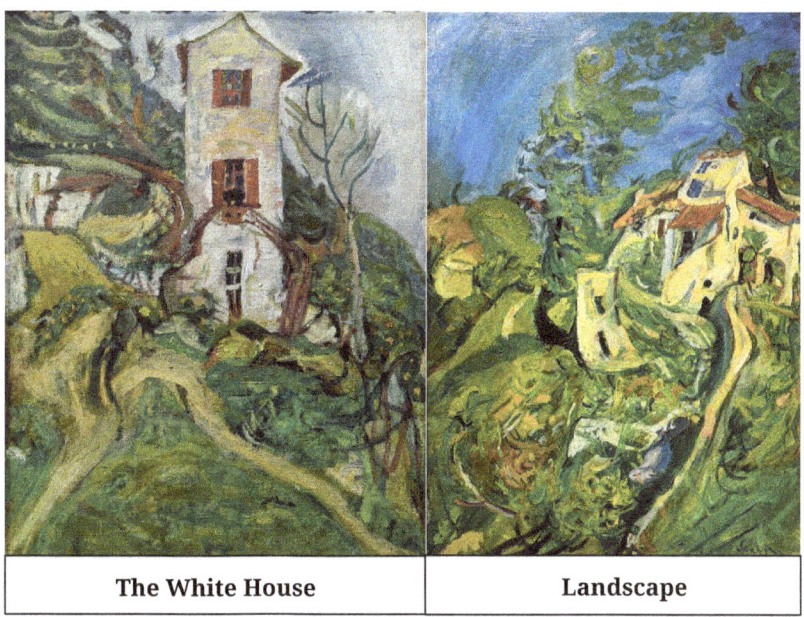

| The White House | Landscape |

The Houses
(Le Maisons)
Here the houses of a small town in the Pyrenees appear. The houses appear completely distorted: they lean and stretch, occupying the entire painting, giving the sensation of a ghostly or nightmare landscape, representing the difficult personal situation he was going through. the painter at that time.
Other paintings painted with this same theme were destroyed by the painter.

Landscape with figures
(Paysage avec personnages)
A path that comes from the right of the painting turns and goes to the

bottom of the composition. Three figures walk along the path.
The trees seem to fall threateningly on the houses. Everything in the landscape trembles in unison, tilts and heads towards the abyss that is sensed to be on the left side.

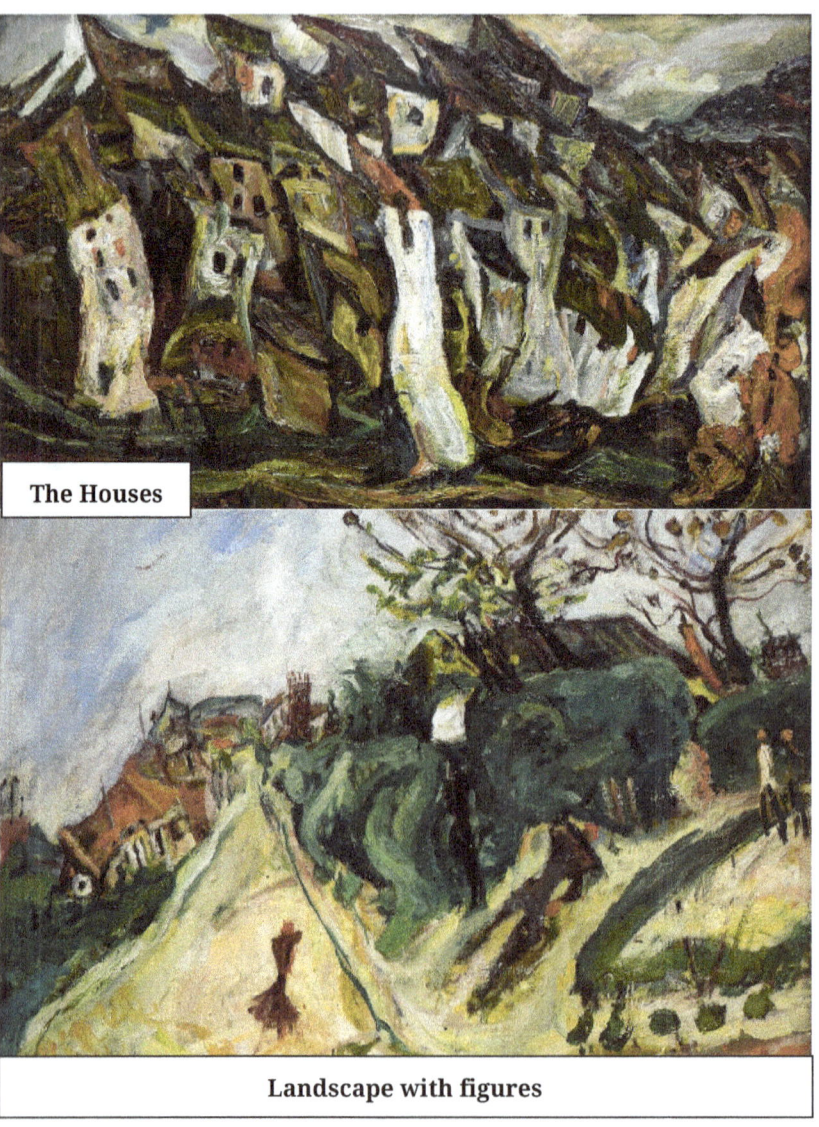

The Houses

Landscape with figures

L'ORANGERIE GUIDE

The Village
The painting is one of the masterpieces of the expressionist style. The objects that make up this daring landscape seem to come to life. With its vibrant, curved, inclined and elongated shapes they express a feeling of pain and frustration that the artist himself wants to express. The entire landscape is confused with Soutine, it is Soutine himself.

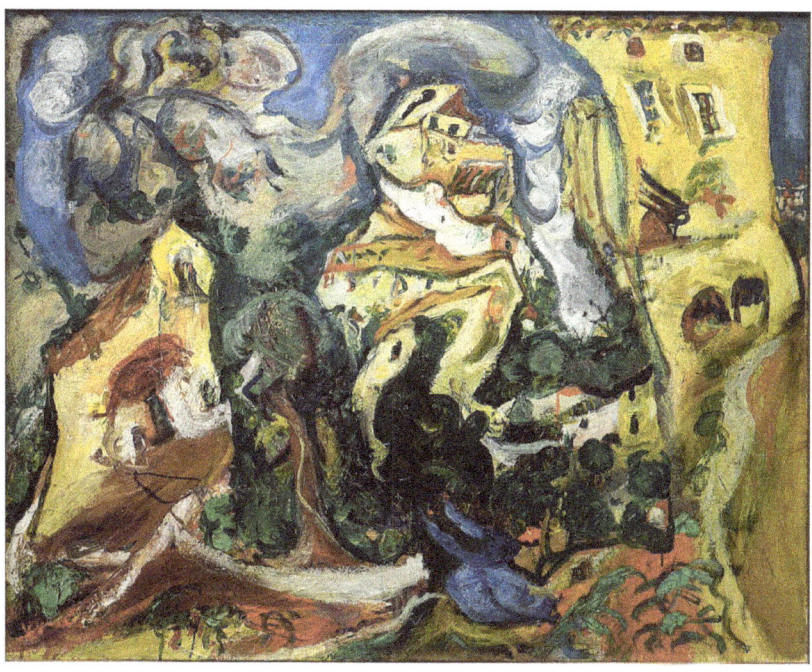

The Big Blue Tree
(Le Gros Arbre bleu)
In this oppressive landscape, the tree trembles with fear.
-In the background, a threatening blue sky that seems to engulf the tree in a white whirlwind.
-On the viewer's right side, in the foreground, a leaning house looks like it will be dragged down the slope.
-On the left side of the painting, in the foreground, two black figures merge with the landscape.

Turkey and tomatoes
(Dindon et tomatoes)
On a horizontal table, a turkey, leaning to the left, and a pile of tomatoes that are joined together against the laws of physics, painted with greater detail than the rest.

We can see the quick, vibrant brushstrokes that shape the animal's body, and the large black spot that looks like putrid liquid emanating from the body and covering one of its legs.

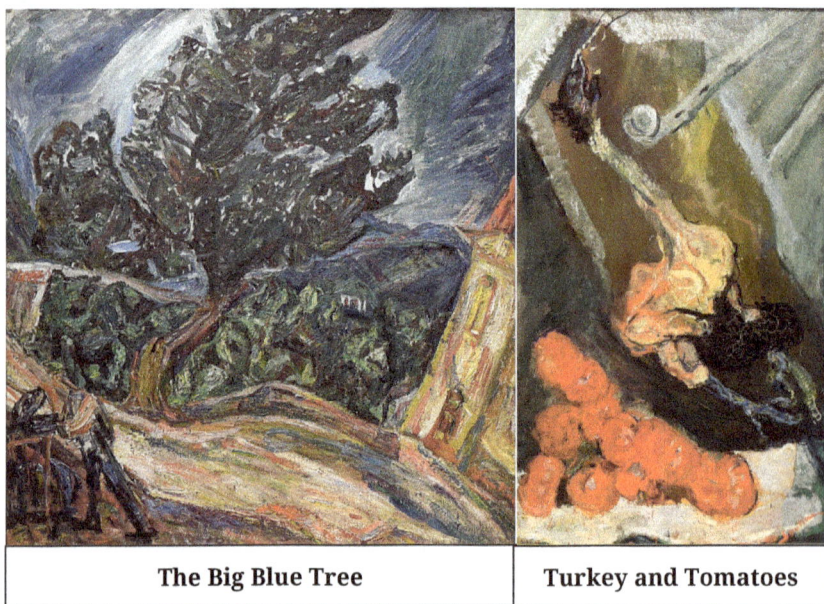

| The Big Blue Tree | Turkey and Tomatoes |

Still life with pheasant
(Nature morte au pheasant)
The pheasant is painted with thick brush strokes, loaded with paint. When looking at the animal, we can see both the feathers and the intestines and the inside of its body lying on a white cloth.
The red pepper can represent a blood stain.
In the background, a jug pouring a strange spoon-shaped orange liquid.

Beef and calf's head
(Boeuf et tête de veau)
It is known that the painter's residence in Paris was near a slaughterhouse.

When Soutine saw the skinned bodies of the oxen, an event came to mind that traumatized him as a child, since he saw a helpless animal killed, and did nothing to save its life.
With thick brushstrokes full of red and yellow he draws the bloody and fat-filled meat of the unfortunate ox.

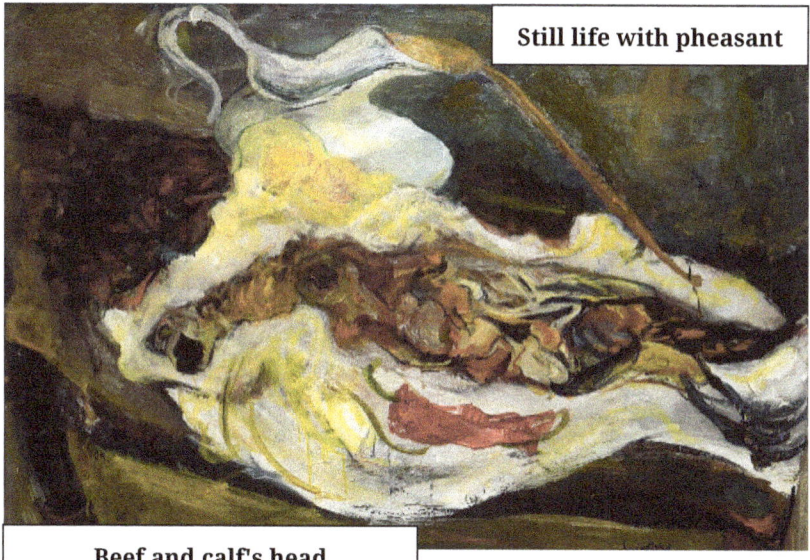

Still life with pheasant

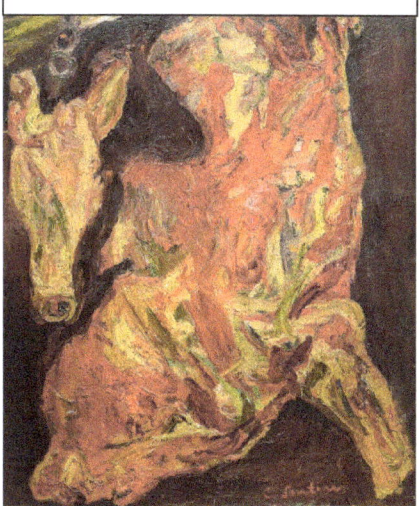

Beef and calf's head

The Plucked Chicken
(The poulet plumé)
The plucked chicken hangs from a hook on a blue-gray background. Its black plumage surrounds its neck.

The Turkey
(Le Dindon)
In this painting with a very distressing atmosphere, the turkey has its beak open and is plucked up to the neck, which seems to express that it was plucked alive. Its legs, twisted by pain, appear painted blue.
On the left, the stain of feathers that were plucked.

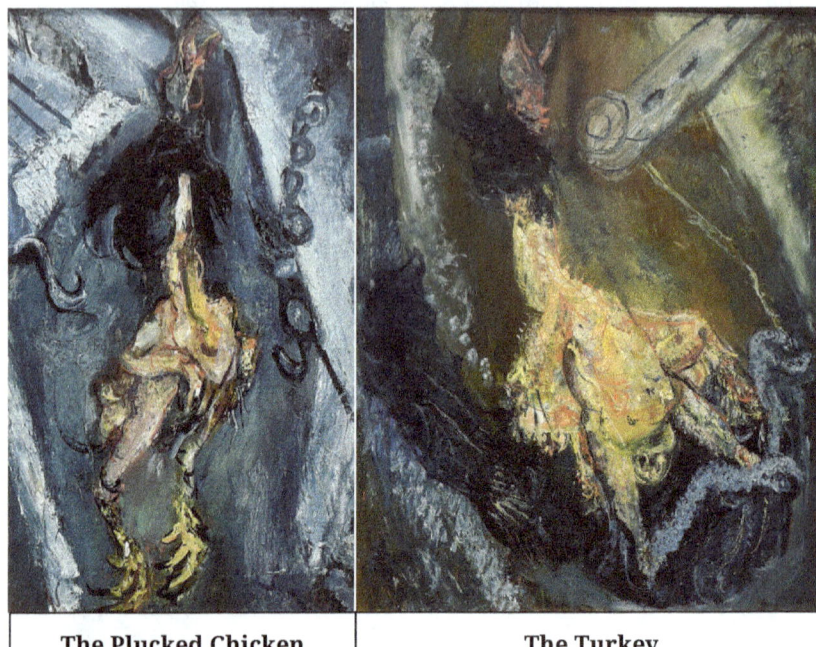

The Plucked Chicken	The Turkey

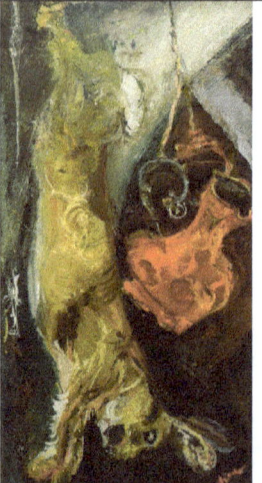

(Le Lapin)

The rabbit appears hanging by its legs, next to a deep red jug, which represents the death of the animal. Its fur is painted with a vibrant brushstroke full of strength.

The Table

In a daring composition, curved lines are played to give movement and life to the objects.

The table appears strangely curved and inclined. The pieces of meat float in the air. The fruit bowl, on the edge of the table, seems to be going to fall.
The coffee pot is held up in the air. The red color of the meat on the table stands out.

L'ORANGERIE GUIDE

The Table

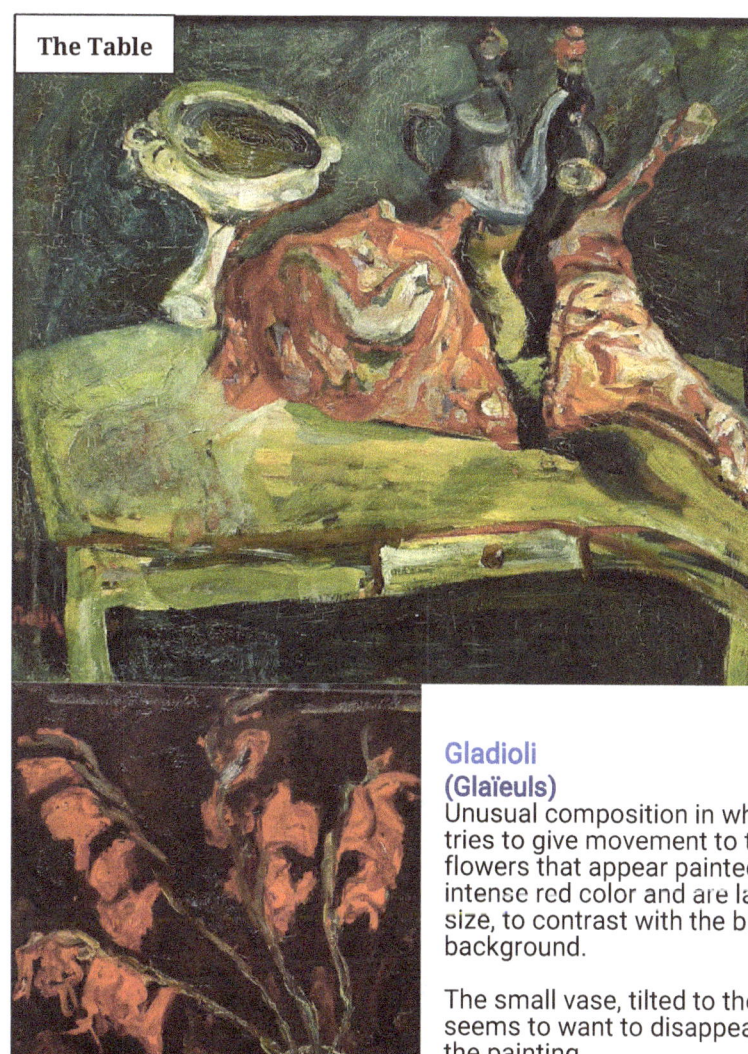

Gladioli (Glaïeuls)

Unusual composition in which he tries to give movement to the flowers that appear painted in an intense red color and are large in size, to contrast with the black background.

The small vase, tilted to the right, seems to want to disappear from the painting.

The brush strokes are very thick and rough, especially the stems. The painting was repainted by the author years after completion.

The Bride
(The Fiancée)
Here we can see the extremely elongated and thin figure of a woman. Her large reddish and white hands, like her arms, face and hair, give her the appearance of a corpse.

The Best Man
(Garçon d'honneur)
The boy dressed in evening clothes rests his hands on his knees. His face expresses sadness. His hands are very big and his legs are very long. We cannot see what he is sitting on.
The background is timeless. The painting represents the sad bourgeoisie of the time, which relies on unknown and hidden businesses.

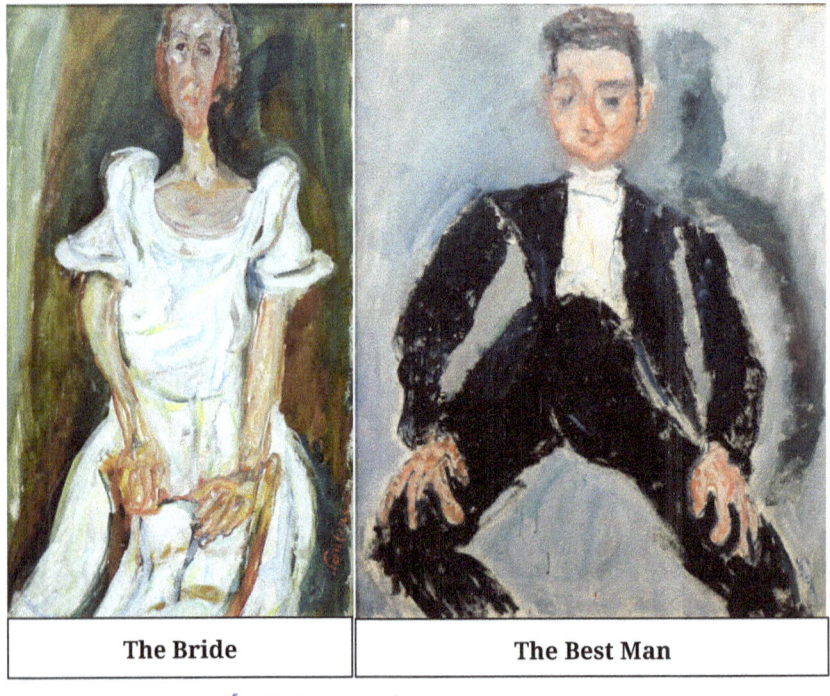

| The Bride | The Best Man |

Portrait of a man (Émile Lejeune)
(Portrait d'homme)
Distorted figure of a man with an elongated face and a tiny, almost imperceptible mouth. This is the painter Émile Lejeune who lived in Paris

and the south of France.

The Floor Waiter
(Le Garçon d'étage)
Here he portrays a hotel waiter with his hands resting on his hips. His face, with a large forehead, tiny mouth and red ears, expresses a gesture of anger and arrogance.
The left shoulder is lower than the right shoulder, which seems to blend in with the dark color of the background.

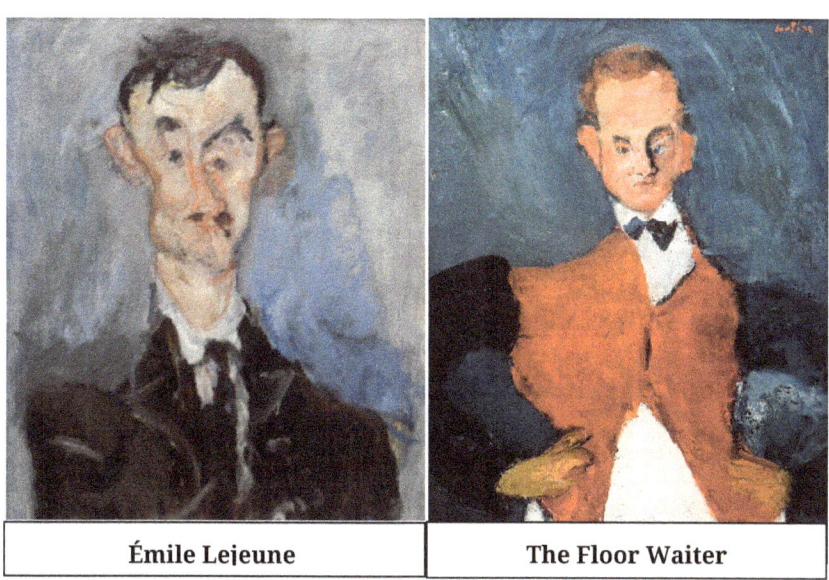

| Émile Lejeune | The Floor Waiter |

The Little Pastry Chef
(Le Petit Patissie)
Portrait of a pastry chef sitting on a chair, his bearing majestic and stately.
The expression on his face reflects surprise and innocence.
His arms are long and disproportionate. He has red ears and a red handkerchief between his hands, which gives the sensation of being cleaned of blood. This work has 6 different versions.
The great collector Guillaime saw this painting during an exhibition, and liked it so much that he became a patron of the painter.

The Choirboy
(L'enfant de Choeur)
In his tireless search to paint with red and white colors, he discovers the altar boys. Here he portrays a stylized boy, of disproportionate height and a frightened face that stands out against a black background.

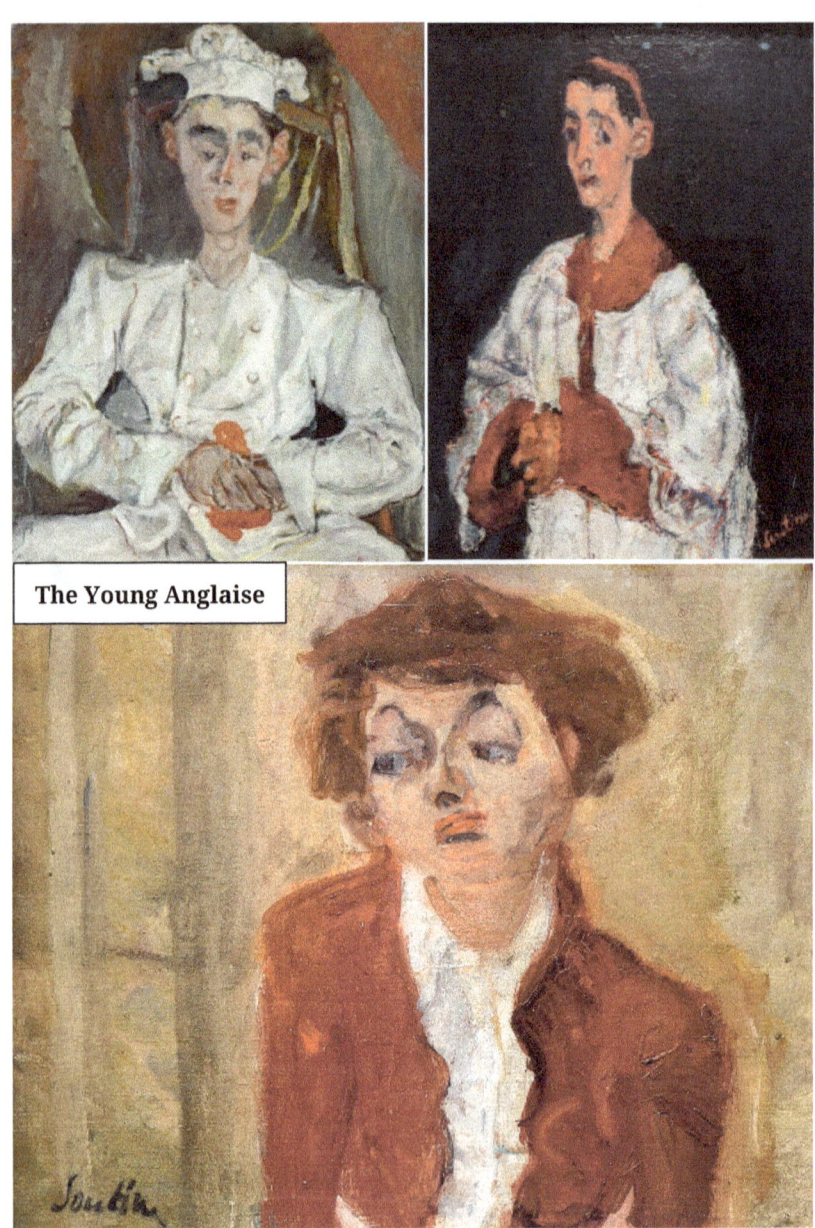

The Young Anglaise

The Young Anglaise
(La Jeune Anglaise)
Portrait of a young woman with a thoughtful look. Her dress is red and white, and her hair is reddish, the artist's favorite colors. The figure stands out against the lighter background.

HENRI MATISSE
(Level -2, Room 8 Arts in Paris)
French painter, he is the great master in the use of color and drawing.

He is one of the great artists of the 20th century, along with Pablo Picasso. His work is influenced by Gauguin and Van Gogh. He was the creator of a new artistic style: Favism.

The son of nurserymen, he studied law, until, during his convalescence due to an illness, he began painting and entered the School of Fine Arts in Paris. He began in figurative art (The Breton Weaver), went on to create some impressionist-style landscapes, and was influenced by Paul Signac's use of color.

He is one of the creators of the Fauvist style, along with André Derain, characterized by extreme simplicity, and a sensual and, apparently, daring use of color (wild, from which the name Fauvism derives), although in reality, very methodical and organized. in search of harmony, calm and spiritual peace. The different color zones create the shapes of the objects.

From this period his works stand out: Luxury, calm and voluptuousness (Luxe, Calme et Volupté), Open window (La fenêtre ouverte), The gypsy (La Gitane), Woman with a hat (Femme au chapeau).

The use of color creates a sense of flat or two-dimensional form in his paintings, which eliminates all depth (Harmony in Red, Still Life with Eggplants), Basket of Oranges (Corbeile d'oranges), The Iris Vase (Le Vase d' iris), with the flowers placed in front of the mirror.

L'ORANGERIE GUIDE

In 1916 he was influenced by the cubist style, with a tendency to use geometric shapes and greater simplicity (Window in Nice).
The use of color becomes increasingly "wild" (the dance, the blouse Romanian...).
The perfect balance between color and shape can only be achieved with extreme simplicity, highly studied and far from improvisation.
"My art seeks balance and tranquility, without anything that worries or worries the spirit, a calming similar to a good armchair."

For color to reach its greatest strength or expressiveness, it is necessary to free it from the slavery of form, using pure tones that reinforce the two-dimensional space and the absence of depth. Almost transparent pigments serve to create luminosity in the painting, an example en On the terrace (Sur la terrasse).
The last stage of his life began in collage (what he called "painting with scissors").

Reclining nude with a drape
(Nu Drapé extend)
(Level -2, Room 11)
The red background serves as a contrast for the white sheet and white pants.

The angles that form elbows, cushions and knees break the rounded and soft contours of the sheets, giving greater strength to the composition. On the side appear the pink marks left by the fabric that covered his body.

Woman with Mandolin
(Femme à la mandoline)
(Level -2, Room 11)
The model is portrayed in the studio that the artist had in Nice, next to the maritime avenue. She appears leaning on the window from which you can see the beach and the sea. She holds a musical instrument in her left hand. His shadow is reflected on the window glass.

Woman with Violin
(Femme au violon)
The opposition between the lines stands out in the painting. The diagonal that forms the figure of the woman extends to the ground, with the bow she carries in her right hand. It opposes the straight drawings of her dress and the straight lines of the table.

The shadows of the table legs form 3 diagonals.
The bright colors stand out as well as the geometric motifs in the background.

L'ORANGERIE GUIDE

The Three Sisters
(Les Trois S urs)
The balance of this careful composition stands out, transmitting serenity. Each of the women is located at a different level of perspective and wears clothes of opposite tones.

Women on the Sofa or Couch
(Femmes au canapé ou Le Divan)
In a narrow and oppressive space there are two women.
The one lying on the couch appears barely outlined and is painted with dark colors, to represent illness and death. The couch is floating above the ground.
The other woman, sitting in the chair, is painted with brighter colors, and accompanies her in this bad moment.
The ground seems to sink at his feet.
The half-open window is the only way out of this stressful space.

The Boudoir
The composition of the painting is reminiscent of the previous one but it is painted with lighter and very fluid colors, and the environment is friendlier and more welcoming. Matisse's daughter is portrayed here, looking at the back of the room and leaning against the window, expressing a certain melancholy on his face.

Odalisque in Red Trousers
(Odalisque à la culotte rouge)
In the painting, the background, beautifully decorated with floral motifs and painted with great detail, is surprising, while the woman's face appears barely sketched with some essential strokes.
The colors are very vivid and intense.

Blue Odalisque or The White Slave
(Odalisque bleue ou L'Esclave blanche)
(Level -2, Room 11)
The figure of the naked woman has an Arabic geometric decoration as a background. The decorations become an essential part of Matisse's works.
The diluted paint stands out, giving the painting a watercolor appearance.

Odalisque in Gray Trousers
(Odalisque à la culotte grise)
In this work, the bright, intense color and geometric shapes invade the painting and surround the woman's body. The intensity of the color,

something characteristic of her work, is taken to the extreme here.
The figure is painted in softer colors and is intended to blend in with the decorations on the gray background and the green table.

ANDRÉ DERAIN

French painter who belonged to Fauvism.

He highlights the strength of his style and its great level of detail. He was influenced by cubism and primitivism.

He was a friend of Henri Matisse, whom he met on one of his visits to the Louvre, with whom he held various exhibitions.
He lived with Pablo Picasso in the Montmartre neighborhood.

He gained a lot of fame with his paintings of the city of London.
He was supported by the poet Apollinaire who got him his first exhibition at the Paul Guillaume Gallery.

Later, he renounced Fauvism and began a period with strong influences from Van Gogh and Cézanne. Later, he began with naturalist painting, following Camille Corot. At the end of the Second World War, he was accused of collaborating with Nazism for participating in an exhibition in Berlin during World War II.
In the final stage of his life, he worked as a theater decorator and book illustrator.

The Golden Age
(L'Age d'Or)
It belongs to the beginning of his Fauvist stage, although characteristics of the neo-impressionist style can still be seen, in the use of pointillism.

The composition evokes a timeless, unreal, mythical place.
-In the center of the painting, in the background, there are two women who dance frantically, where the whiteness of their clothes stands out, making the attention central. Around them is a group of naked women who are walking, washing or sunbathing.
It symbolizes eternal happiness, the golden age of humanity, where there

is no suffering or pain.
-In the foreground, the colors are dark and gloomy and three female figures appear.
- the first woman, looking rigid and cold, raises her arms in alarm.
-A second woman rushes towards her with a disoriented look.
-A third woman lowers her head, a sign of an imminent and unsolvable misfortune.
-On the right side, an unknown danger scares them.
It is kept here on loan from the Iranian Art Museum.

Landscape of Provence
(Paysage de Provence)
This small town in the south of France appears completely desolate and lifeless, surrounded by fields without vegetation and totally dry from the strong summer sun.
In the foreground, some huge rocks and a dry tree accentuate the desolation.
In the medium plane, the different tones of the fields stand out.
In the background, the contours of the houses, which are barely outlined and merge with the small hill.
Derain once said that the way heaven and earth come together creates drama or the greatest happiness.

Landscape of the South
(Paysage du Midi)
This landscape, more friendly and lively than the previous one, represents another town in the south of France. In the foreground a stone bridge with a dry riverbed. However, the green tones stand out, and the tall trees on the right, with their greenish trunks.

The Road
(La route)
The light envelops the landscape, a peaceful and calm light that comes from the viewer's right and illuminates the path, giving shape to the shadows of the trees, of great greenery, that are located on both sides of the path, welcoming the walker.
Green fields surround the small town where all its buildings can be clearly distinguished, despite the distance.
The painter uses warm colors to achieve this feeling of peace and harmony.

The Big Tree
(Le Gros Arbre)
(Level -2, Room 12)
In this work we can see the influence of Cezanne, especially in the use of color. He always admired these living cathedrals that, in his opinion,

contain the great mystery of nature.

La Gibecière
The painting reproduces a baroque style still life, but there is a big difference in how the objects are reproduced: curtains, jug, glass cup, whose geometric lines are reminiscent of cubism.
The luminosity of the foreground stands out, and the darker area of the background.

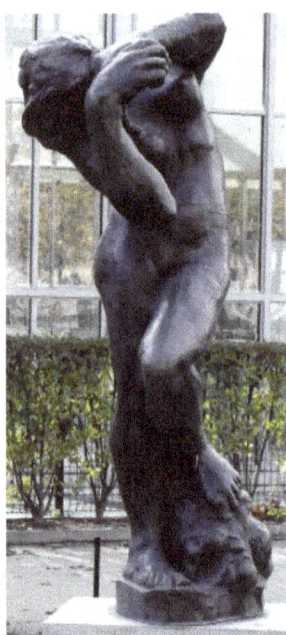

Still life with Basket
(Nature morte au panier)
(Level -2, Room 12)
Simple composition endowed with modernity by the use of thick white brush strokes to create reflections in the objects, and thick black brush strokes for the shadow of the contours.

Still life with a glass of wine
(Nature morte au verre de vin)
Derain uses colors here in such a way as to eliminate the outlines of objects.

The right part of the composition is dominated by shadows, while the left is more illuminated.
The color of the pear is opposite to that of the grapes. The piece of bread and the glass of wine are the brightest objects and cast their shadows on the table.

Pears and Jug
(Poires et cruche)
Long, thick brush strokes characterize this small composition that looks like a sketch. For example, the yellow reflection on the table and the handle of the jug are painted with a single touch of the brush, which is clearly visible.

The Kitchen Table
(La Table de cuisine)
(Level -2, Room 8 Arts in Paris)
This composition of kitchen utensils on a table is very careful and detailed. It is worth highlighting the placement that the objects form a

cross. In the foreground are those with straight lines. In the background are those with curved lines.

Country still life
(Nature morte champêtre)
(Level -2, Room 12)

This curious composition symbolizes the arrival of spring: the sun, the flowers, the songs of the birds. The objects seem to be floating in the air, moving to the rhythm of the music.

Melon and fruits

This painting is full of color and light that creates the shapes of the objects. The background is orange and the table is yellow. On the table are some vine leaves, a melon, some grapes and some peaches, symbols of spring.
It is characterized by using very fluid paint.

Roses on a Black Background
(Roses sur fond noir)

The vase on which the flowers are located blends into the dark background. On the right is a glass container filled with water on which a flower floats to give strength to the composition.

Roses in a Vase
(Roses dans un vase)

The flowers contrast against the dark background.

Nude on the Sofa
(Nu au canapé)

The painter represents Raymonde Knaublich, model and partner of the painter with whom Derain had a son.
The uncomfortable position in which she is lying stands out. Her legs are painted with long brush strokes.
The contrast between the model's body, in lighter tones, and the dark green background stands out.

Large Reclining Nude
(Grand nu couché)

The woman is lying with her arm resting on the sand, her muscles tense and her face in a reflective attitude. The body is painted with light and bright tones to contrast with the background. The outline of the figure is reinforced with shadowed areas.
The landscape in the background is unreal, artificial, reduced to a minimum, a blue-green square meets a clear blue sky.

Nude with Jug
(Nu à la cruche)
A very natural-looking naked woman is sitting on a rock. Her head is reclined and her face with large eyes looks nowhere, looking like a medieval religious painting.
The area of water on the right seems to want to join the sky, eliminating the fragile mountain that separates them.

The Beautiful Model
(The Beau model)
The very dark background highlights the woman's luminous body with grayish reflections, and whose contours are not clear.
The model poses by letting her hair fall with her hand, bending her arm and leg.

The Dancer Sonia
(La Danseuse Sonia)
We can see the portrait of the famous dancer Sonia Gaskell. She rests her hand on her neck and her face expresses fatigue.
The painter met the dancer when he was making sets for the theater.

The Painter's Niece
(The Nièce du peintre)
Geneviève was portrayed on numerous occasions by her uncle, with whom she lived and whom she helped in his tasks. Here we can see her with one of his legs resting on the chair, and the tip of his foot on the floor, in an unnatural pose, looking at the viewer with his big eyes, holding a hat and a bouquet of flowers.

The Painter's Niece Seated
(The Nièce du peintre assise)
The composition expresses calm and harmony. The painter's niece looks towards infinity with her face in a reflective attitude and a certain air of innocence.
Her dress is painted with very light and bright colors that contrast with the dark background. She rests one hand on the arm, painted with long brush strokes, while the other arm is painted with shorter brush strokes, as is the neck.

Portrait of Madame Paul Guillaume with the big hat
(Portrait of Madame Paul Guillaume au grand chapeau)
(Juliette Lacazze or Domenica the diabolical)
Naturalistic style painting. A powerful luminosity comes out of the dress and body of this woman. Her gaze is enigmatic and haughty, and her

bearing is elegant. In the background, the painting Harlequin and Pierrot appears.
Domenica hung her portrait in the bedroom as expressed by her husband, Paul Guillaume.

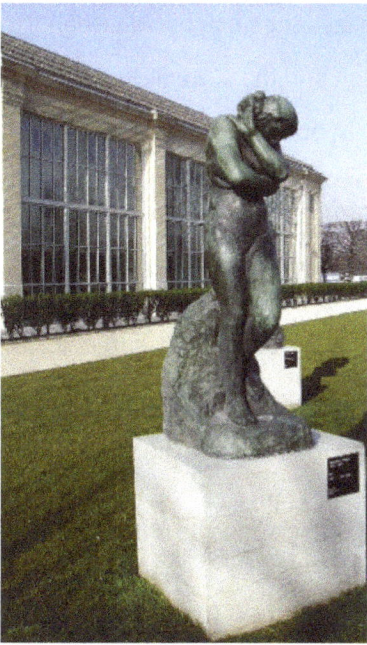

Portrait of Paul Guillaume
This painting was painted when the businessman and protector of artists. He appears here with a luminous face. He has a lost gaze and is absorbed in his thoughts. He holds a cigarette in one hand and has his arm resting on a book. The background is ethereal.

Harlequin and Pierrot
(Arlequin et Pierrot)
(Level -2, Room 8 Arts in Paris)
Painting made at the request of Paul Guillaume, patron of the painter. The two theatrical characters of the Italian comedy are represented here: Harlequin with his three-cornered hat, and Pierrot with his white coat, dancing while playing the guitars. His face is serious and something sad. The painter has portrayed Paul Guillaume himself in Pierrot.

Harlequin on guitar
(Arlequin à la guitare)
(Level -2, Room 8 Arts in Paris)
The figure rests the guitar on his left leg. His cold and distant face does not look anywhere. It seems that he wants to start dancing.
The landscape background is unreal and timeless.

The Black Man with the Mandolin
(Le Noir à la mandoline)
On a very light and empty background, the figure of a musician in a white shirt, playing a mandolin. The composition is characterized by the strong contrasts of colors that we can see in the shirt, in the arm and hands of the musician, as well as in the musical instrument.

PICASSO

During his first stage (blue period), his works were influenced by Toulouse-Lautrec and El Greco, and, to a lesser extent, by Van Gogh and Gauguin.
He was a friend of the writer André Breton and the surrealist poet Guillaume Apollinaire. The latter blamed Picasso for the theft of the Mona Lisa, which occurred in 1911. Finally, both were declared innocent.

-In the blue or melancholy stage, the figures of the circus artists appear in a timeless environment. It only uses blue tones.
-In the pink stage or existential joy, the softness of the lines, the elongated figures and the use of very soft colors stand out.
-Following Derain's advice, he focused on African and Polynesian art (primitivism). The colors are filled with light.

Picasso and Matisse were rivals and friends. Matisse once said that no one had looked at his work like Picasso, and no one had looked at Picasso's work like him.
-In the cubist stage, shapes become geometric, they are broken and reconstructed in different superimposed planes.
A new depth is created to the painting without having to use traditional perspective. The use of light accentuates the contours.
In the second cubist stage, real forms are torn apart not to reconstruct them but to create a different reality.
-In his tireless journey to explore the world of art, Picasso came to create neoclassical sculptures representing women and children.
An example is his Three Women at the Fountain, which we can see in this museum.

Woman in a White Hat
(Femme au chapeau blanc)
(Level -2, Room 8 Arts in Paris)
Here Picasso portrays his first wife in a pensive attitude, with her arm resting on the chair.
The arms and hands are disproportionately thick.
Light tones dominate the entire painting.

The Embrace
(L'Étreinte)
It belongs to Picasso's blue or melancholic period. A naked man and a woman embrace each other. They rest their heads on each other's shoulders. We cannot see their faces. The woman is pregnant.

The Adolescents
(Les Adolescents)
It belongs to his pink stage, which will lead him to neoclassicism. Two very stylized young nudes with hardly any details. The entire composition has a single color.

Three Women at the Fountain
(Femmes à la fontaine)
With this work Picasso began his neoclassical period, characterized by pink tones. We can see here the sketch of the painting that is kept in the MOMA Museum in New York.
The three robust-looking women wear clothes from classical antiquity.

Large nude in the drapery
(Grand nu à la draperie)
Here Picasso experiments with the neoclassical style, giving it his personal touch. The female figure, robust and rocky in appearance, has a gigantic hand and closed eyes. The pink color predominates.

Large Bather
Grande baigneuse
(Level -2, Room 8 Arts in Paris)
It belongs to the neoclassical or figurative style, which the painter called: the return to order. The robustness and heaviness of the female figure of gigantic proportions, follows the classical canons to overcome and reconstruct them.

Woman with a Comb
(Femme au peigne)
Painted before Nu sur fond rouge. Here the apparent realism gives way to a new style. The large size of the head, the simplification of the features of the face, the breasts and the pubis, as well as the exaggerated inclination of the body.

Nude on a Red Background
(Nu sur fond rouge)
It was painted after Femme au comb (woman with a comb) and before

Les Demoiselles d'Avignon. It is one of the precursor paintings of his cubist period. These characteristics can be seen in the geometric simplification of the woman's body, the distortion of the arm and the empty eyeballs.

Woman with Tambourine
Femme au tambourin
(Level -2, Room 8 Arts in Paris)
Picasso returns to cubism, creating different planes in the same space to break down the shape of the figure.

Large Still Life
(Grande nature morte)
This was the only Cubist style painting kept by Paul Guillaume's widow. The typical objects of a simple still life are represented from different perspectives, superimposing the planes.

Composition: Peasants (1906)
(Composition : Paysans)
Sketch with two very stylized figures, and, above them, some flowers. Quick, short brush strokes predominate. There are also characteristic elements of the blue period on the young woman's face.

MAURICE UTRILLO
French painter assigned to the Paris school, to which Modigliani and Marc Chagall belonged, influenced by different artistic currents and his own style.
Son of the model painter Suzanne Valadon, a Renoir model.
From his parents he learned to lead an eccentric, idle and disorderly life. His style was realistic with a more daring use of form and colors. He painted rural landscapes and different areas of Paris:
Notre-Dame Cathedral, Orleans Cathedral, churches of Montmartre, in Paris, stately homes, such as Berlioz's, as well as government buildings.

He was a friend of Modigliani and Chaïm Soutine, rejecting the environment of Matisse and Picasso.
During his life, all his work was very little valued, and he could barely live.

KEES VAN DONGEN
Dutch painter who belonged to German Expressionism and Fauvism, along with Matisse and Derain
His father was a manufacturer from Geneva. He studied painting in Rotterdam where he led an idle and disorderly life, frequenting nightlife and brothels. In his paintings he portrayed sailors and port prostitutes.
He also worked as an illustrator and famous portraitist of rich businessmen. His lavish parties are known where his overwhelming personality made it easy for him to get new clients.
In 1941, he agreed to participate with André Derain and other painters in an exhibition organized by Nazism. Although he could be accused of collaboration, he was never denounced. His style is characterized by intense colors.

MARIE LAURENCIN
French painter of simple forms similar to the cubist and nymphist style.
She belonged to the Puteaux group (Section d'Or).

She was the out-of-wedlock daughter of a Republican deputy, and began working as a painter at the well-known Sèvres porcelain factory.
In Paris she met Georges Braque, one of the fathers of Cubism, as well as Picasso and Apollinaire, with whom she had a romantic relationship.
His style began with Fauvism and Cubism, using soft gray and pink colors, representing very simple compositions with female figures that

seem to fly or levitate in a timeless environment.
After her divorce she started wearing much darker tones.
She was the first woman to hold an individual exhibition with all her works, in 1912. Her artistic representative was the well-known poet Apollinaire.

Prestigious illustrator, she made the most beautiful illustrations of the book: Alice in Wonderland by Lewis Carroll. She was a costume designer for the most important theaters in Paris.
He portrayed Helena Rubinstein and the designer Coco Chanel.

Copyright2024.L'Orangerie Guide.Published by Baltasar Rodríguez art Kindle.

Acknowledgements
https://upload.wikimedia.org/wikipedia/commons/thumb/e/e5/Kees_van_Dongen_1923.jpg/Bibliothèque nationale de France Author Agence de presse Meurisse
https://commons.m.wikimedia.org/wiki/File:Maurice_Utrillo,_par_Suzanne_Valadon.jpg
https://upload.wikimedia.org/wikipedia/commons/thumb/7/7c Ricostruzione_dell'interno_di_rue_du_cirque_3_dove_abitò_domenica_walter%2C_vedova_di_paul_guillaume.JPG/Sailko
http://ro.wikipedia.org/ wiki/Fi %C8%99ier:Utrillo01.jpg
https://upload.wikimedia.org/wikipedia/commons/thumb/b/b8/Portrait_de_Picasso%2C_1908.jpgPhoto(C) RMN-Grand Palais
https://upload.wikimedia.org/wikipedia/commons/thumb/9/9a/Soutine-2014-18.jpg/Photographie numérique
https://upload.wikimedia.org/wikipedia/commons/thumb/c/c8/Chaïm_soutine%2C_la_fidanzata%2C_1923_ca.JPG/Sailko
https://upload.wikimedia.org/wikipedia/commons/thumb/b/bb/Chaïm_soutine%2C_gladioli%2C_1919_ca..JPG/Sailko
https://upload.wikimedia.org/wikipedia/commons/thumb/0/00/Gauguin_paysage_1901.jpg/Siren-Com
https://upload.wikimedia.org/wikipedia/commons/thumb/5/51/Paul_Cézanne_-_Le_Déjeuner_sur_l'herbe_(Orangerie).jpg/https://www.cezannecatalogue.com/catalogue/entry.php?id=944
https://fr.m.wikipedia.org/wiki/Fichier:Pierre-Auguste_Renoir_-_Gabrielle_au_jardin.jpg Renoir Source / photographe Source inconnue
https://upload.wikimedia.org/wikipedia/commons/thumb/c/c2/Chaïm_Soutine_-_Le_Petit_Pâtissier.jpg/http://www.musee-orangerie.fr/
https://upload.wikimedia.org/wikipedia/commons/thumb/b/b8/Soutine-2014-13.jpg/Photographie numérique
https://upload.wikimedia.org/wikipedia/commons/thumb/8/89/Soutine-2014-04.jpg/Photographie numérique
https://upload.wikimedia.org/wikipedia/commons/thumb/d/de/Soutine-2014-17.jpg/Photographie numérique
https://upload.wikimedia.org/wikipedia/commons/thumb/0/0c/Paul_cézanne%2C_madame_cézanne_in_giardino%2C_1879-80.JPG/Sailko
https://upload.wikimedia.org/wikipedia/commons/thumb/5/5d/Soutine-2014-01.jpg/Photographie numérique
https://upload.wikimedia.org/wikipedia/commons/thumb/9/99/Soutine-2014-11.jpg/Photographie numérique
https://upload.wikimedia.org/wikipedia/commons/thumb/a/a2/Soutine-2014-06.jpg/Photographie numérique
https://upload.wikimedia.org/wikipedia/commons/thumb/0/04/Soutine-2014-09.jpg/Photographie numérique
https://upload.wikimedia.org/wikipedia/commons/thumb/5/56/Soutine-2014-07.jpg/Photographie numérique
https://upload.wikimedia.org/wikipedia/commons/thumb/1/15/Soutine-2014-08.jpg/Photographie numérique
https://upload.wikimedia.org/wikipedia/commons/thumb/8/8e/Paul_Cézanne_-_Portrait_of_Madame_Cézanne_-_Google_Art_Project.jpg/YgGTzo7pRWiPIg at Google Cultural Institute maximum zoom level
https://upload.wikimedia.org/wikipedia/commons/thumb/2/2e/Paul_Cézanne_-_Straw-Trimmed_Vase%2C_Sugar_Bowl_and_Apples_-_Google_Art_Project.jpg/kwEpEFvxnyne9A at Google Cultural Institute maximum zoom level
https://upload.wikimedia.org/wikipedia/commons/thumb/f/f6/Paul_Cezanne_Fruits_serviette_et_boîte_à_lait_(1880-1881)_RF_1960-10.jpg/xiquinhosilva from Cacau
https://upload.wikimedia.org/wikipedia/commons/thumb/f/f7/Nature_morte_aux_pommes_et_pâtisseries%2C_par_Paul_Cézanne.jpg/The Yorck Project (2002) 10.000 Meisterwerke der Malerei (DVD-ROM), distributed by DIRECTMEDIA Publishing GmbH. ISBN : 3936122202 .
https://upload.wikimedia.org/wikipedia/commons/thumb/7/72/Paul_cézanne%2C_barca_e_bagnanti%2C_1890_ca._03.JPG/Sailko
https://commons.wikimedia.org/wiki/File:Paul_cézanne,_barca_e_bagnanti,_1890_ca._01.JPGSailko
https://upload.wikimedia.org/wikipedia/commons/thumb/5/57/Flowers_in_a_Blue_Vase_by_Paul_Cézanne%2C_1880.JPG/Joconde: 00000089428
https://upload.wikimedia.org/wikipedia/commons/thumb/3/39/Paul_cézanne%2C_paesaggio_con_tetti_rossi_(i

L'ORANGERIE GUIDE

l_pino_a_l'estaque)%2C_1875-76%2C_02.JPG/Sailko
https://upload.wikimedia.org/wikipedia/commons/thumb/3/3c/Portrait_du_fils_de_l'artiste%2C_par_Paul_Cézanne%2C_IMG_2125.jpg/Deroravi
https://upload.wikimedia.org/wikipedia/commons/thumb/9/96/Paul_Cézanne_-_The_Red_Rock_-_Google_Art_Project.jpg/5QH9Zae_lPTZzA at Google Cultural Institute
https://upload.wikimedia.org/wikipedia/commons/thumb/7/75/Paul_Cézanne_-_Fleurs_et_fruits_(Orangerie).jpg/https://www.cezannecatalogue.com/catalogue/entry.php?id=461
https://upload.wikimedia.org/wikipedia/commons/thumb/e/e4/Paul_cézanne%2C_ritratto_della_figlia_dell'artista%2C_1881-82.JPG/Sailko
https://upload.wikimedia.org/wikipedia/commons/thumb/e/ef/Nature_morte%2C_poire_et_pommes_vertes.JPG/Miguel Hermoso Cuesta
https://upload.wikimedia.org/wikipedia/commons/thumb/9/9a/Le_Jour_ni_l'Heure_7643_%2C_Paul_Cézanne%2C_1839-1906%2C_La_Barque_et_les_baigneurs%2C_c._1890%2C_dét.%2C_Paris%2C_musée_de_l'Orangerie%2C_dimanche_5_mai_2019%2C_15-09-34_-_Flickr_-_Renaud_Camus.jpg/Renaud Camus from Plieux, France
https://upload.wikimedia.org/wikipedia/commons/thumb/4/48/Paul_Cézanne_-_Arbres_et_maisons.jpg/https://www.cezannecatalogue.com/catalogue/entry.php?id=536
https://upload.wikimedia.org/wikipedia/commons/thumb/4/48/Sisley_Orangerie_02.jpg/Miguel Hermoso Cuesta
https://upload.wikimedia.org/wikipedia/commons/thumb/b/b1/Amedeo_Modigliani_-_The_Young_Apprentice_-_Google_Art_Project.jpg/xwHqOD6ZKWvxCA at Google Cultural Institute
https://upload.wikimedia.org/wikipedia/commons/thumb/4/46/Amedeo_Modigliani_-_Paul_Guillaume%2C_Novo_Pilota_-_Google_Art_Project.jpg/Joconde: 00000089486Source/Photographer egGdt6G4tsL9nQ at Google Cultural Institute
https://upload.wikimedia.org/wikipedia/commons/thumb/a/a2/Amedeo_Modigliani_-_Fille_rousse.jpg/Unknown source
https://upload.wikimedia.org/wikipedia/commons/9/9a/Amedeo_Modigliani_-_Femme_au_ruban_de_velours.jpg Unknown source
https://commons.m.wikimedia.org/wiki/File:Amedeo_Modigliani_-_Antonia.jpgUnknown source
https://upload.wikimedia.org/wikipedia/commons/thumb/5/56/Soutine-2014-07.jpg/Joconde: 00000089548 Source/Photographer Photographie numérique
https://upload.wikimedia.org/wikipedia/commons/thumb/5/5e/Soutine-2014-10.jpg/Q21853449 Joconde: 00000089538 Photographie numérique
https://upload.wikimedia.org/wikipedia/commons/thumb/7/7c/Soutine-2014-05.jpg/Q21856344 Joconde: 00000089545 Photographie numérique
https://upload.wikimedia.org/wikipedia/commons/thumb/0/0e/Pommes_et_biscuits_(P._Cézanne%2C_Musée_de_lOrangerie)_(4612845938).jpg/Pommes et biscuits (P.Cézanne,Musée del'Orangerie) Autor dalbera from Paris, France
https://upload.wikimedia.org/wikipedia/commons/thumb/e/eb/Le_pin_à_l'Estaque_(P._Cézanne%2C_Musée_de_l'Orangerie).jpg/Q22337856 Joconde: 00000089427 Origen/Fotògraf Flickr : Le pin à l'Estaque (P. Cézanne, Musée de l'Orangerie)
https://fr.m.wikipedia.org/wiki/Fichier:Paul_Cézanne_-_Dans_le_parc_de_Château_Noir.jpgQ22337828 Joconde: 00000089439
https://upload.wikimedia.org/wikipedia/commons/thumb/4/4a/Soutine-2014-16.jpg/Q21856351 Joconde: 00000089554 Photographie numérique
https://upload.wikimedia.org/wikipedia/commons/thumb/8/83/Soutine-2014-03.jpg/Q21856353Joconde: 00000089543 Photographie numérique
https://upload.wikimedia.org/wikipedia/commons/thumb/5/59/Soutine-2014-12.jpg/Q21856367 Joconde: 00000089558 Photographie numérique
https://upload.wikimedia.org/wikipedia/commons/thumb/c/ca/Soutine%2C_La_Table%2C_c._1919.jpg/http://www.musee-orangerie.fr/fr/oeuvre/la-tableSource/Own work
https://upload.wikimedia.org/wikipedia/commons/thumb/f/f1/Soutine-2014-02.jpg/Q21856371Joconde: 00000089556 Photographie numérique
https://upload.wikimedia.org/wikipedia/commons/thumb/8/84/Soutine-2014-14.jpg/Q21856387 Joconde: 00000089542 Photographie numérique
https://upload.wikimedia.org/wikipedia/commons/thumb/2/2a/Claude_Monet_-_The_Water_Lilies_-_The_Clouds_-_Google_Art_Project.jpg/YQEt9_UVgiL-Og at Google Cultural Institute
https://upload.wikimedia.org/wikipedia/commons/thumb/c/ce/Claude_Monet_(musée_de_lOrangerie%2C_Paris)_(8231007934).jpg/Jean-Pierre Dalbéra from Paris, France
https://upload.wikimedia.org/wikipedia/commons/thumb/2/26/Claude_Monet_-_The_Water_Lilies_-_Clear_Morning_with_Willows_-_Google_Art_Project.jpg/Q28797618 Joconde: 000PE003982 Source/7QHpOuLSwKTH8A at Google Cultural Institute
https://upload.wikimedia.org/wikipedia/commons/thumb/7/7e/Claude_Monet_-_The_Water_Lilies_-_Green_Reflections_-_Google_Art_Project.jpg/wEwoHEvFukepQ at Google Cultural Institute
https://upload.wikimedia.org/wikipedia/commons/thumb/f/fc/Claude_Monet_-_The_Water_Lilies_-_Morning_-_Google_Art_Project.jpg/IAHgEdqp703amQ at Google Cultural Institute
https://upload.wikimedia.org/wikipedia/commons/thumb/6/66/Claude_Monet_-_The_Water_Lilies_-_Setting_Sun_-_Google_Art_Project.jpg/qAG-qyFHUPm1kg at Google Cultural Institute
https://upload.wikimedia.org/wikipedia/commons/a/a2/Claude_Monet_-_The_Water_Lilies_-_The_Two_Willows_

L'ORANGERIE GUIDE

-_Google_Art_Project.jpg3AEQUJnQ8YnB_A at Google Cultural Institute
https://upload.wikimedia.org/wikipedia/commons/thumb/7/71/Henri_Rousseau%2C_dit_le_Douanier_-_The_Wedding_Party_-_Google_Art_Project.jpg/eAGtJRGu8YRJiAat Google Cultural Institute
https://upload.wikimedia.org/wikipedia/commons/thumb/a/a8/Henri_rousseau_il_doganiere%2C_la_nave_nella_tempesta%2C_1899_ca._02.JPG/Sailko
https://upload.wikimedia.org/wikipedia/commons/thumb/a/af/Françoise_Foliot_-_Henri_Rousseau_-_Pêcheurs_à_la_ligne.jpg/Françoise Foliot
https://upload.wikimedia.org/wikipedia/commons/thumb/1/16/Françoise_Foliot_-_Henri_Rousseau_-_La_Fabrique_de_chaises_à_Alfortville.jpg/Françoise Foliot
https://commons.m.wikimedia.org/wiki/File:Henri-Julien_Félix_Rousseau_-_La_Carriole_du_Père_Junier.jpgQ21849420 Joconde: 00000089535 Henri Rousseau
https://upload.wikimedia.org/wikipedia/commons/thumb/5/5e/Rousseau_L'Enfant_à_la_poupée_Orangerie_RF1963-29.jpg/Joconde: 00000089533 User:Bibi Saint-Pol.
https://commons.m.wikimedia.org/wiki/File:Henri-Julien_Félix_Rousseau_-_La_Fabrique_de_chaises.jpgQ60300695 Joconde: 00000089529
https://upload.wikimedia.org/wikipedia/commons/thumb/c/c6/Françoise_Foliot_-_Henri_Rousseau_-_La_Falaise.jpg/Françoise Foliot
https://upload.wikimedia.org/wikipedia/commons/thumb/e/ee/Rousseau_-_Promeneurs_dans_un_parc%2C_entre_1900_et_1910%2C_RF_1963_30.jpg/https://www.musee-orangerie.fr/fr/collections/recherche?search=Rousseau+&sort_by=search_api_relevance&items_per_page=15&search_type=simple_search&display_type=grid
https://upload.wikimedia.org/wikipedia/commons/thumb/0/00/Gauguin_paysage_1901.jpg/ Siren-Com
https://commons.m.wikimedia.org/wiki/File:Pierre-Auguste_Renoir_-_Femme_accoudée.jpgQ3713905 Joconde: 00000089526 Pierre-Auguste Renoir
https://commons.m.wikimedia.org/wiki/File:Pierre-Auguste_Renoir_-_Femme_nue_couchée_(Gabrielle).jpgQ3742370 Joconde: 00000089519 Pierre-Auguste Renoir
https://upload.wikimedia.org/wikipedia/commons/thumb/6/6f/Femme_Nue_dans_un_Paysage%2C_by_Pierre-Auguste_Renoir%2C_from_C2RMF_cropped.jpg/File:Femme Nue dans un Paysage, by Pierre- Auguste Renoir, from C2RMF.jpg C2RMF: Galerie de tableaux en très haute définition
https://upload.wikimedia.org/wikipedia/commons/thumb/e/e5/Gabrielle_et_Jean%2C_by_Pierre-Auguste_Renoir%2C_from_C2RMF_cropped.jpg/Gabrielle et Jean, by Pierre-Auguste Renoir, from C2RMF.jpg , originally C2RMF: Galerie de tableaux en très haute définition
https://upload.wikimedia.org/wikipedia/commons/thumb/0/06/Auguste_Renoir_-_Claude_Renoir_in_Clown_Costume_-_Google_Art_Project.jpg/Q3793475 Joconde: 00000089522 Photographer YAGrVhWmRjsc9A at Google Cultural Institute
https://upload.wikimedia.org/wikipedia/commons/thumb/5/53/Pierre-Auguste_Renoir_-_Yvonne_et_Christine_Lerolle_au_piano.jpgQ4023318 Joconde: 00000089515 Photographer
http://www.renoirgallery.com/painting.asp?id=212
https://upload.wikimedia.org/wikipedia/commons/thumb/1/14/Auguste_Renoir_(musée_de_lOrangerie%2C_Paris)_(8264090415).jpg/Jean-Pierre Dalbéra
https://upload.wikimedia.org/wikipedia/commons/thumb/1/10/Auguste_Renoir_-_Snow-covered_Landscape_-_Google_Art_Project.jpg/Q20643496 Joconde: 00000089513 Photographer GgHofvuPkA8VpA at Google Cultural Institute
https://upload.wikimedia.org/wikipedia/commons/thumb/4/48/Pierre-Auguste_Renoir_-_Baigneuse_aux_cheveux_longs_(1).jpg/Q21730632 Joconde: 00000089505 Renoir, peintre du bonheur : 1841-1919, de Gilles Néret, Köln, Taschen, 2001, p. 328. ISBN 9783822857410
https://upload.wikimedia.org/wikipedia/commons/thumb/b/be/Pierre-Auguste_Renoir_-_Coco_jouant.jpg/Q21730711 Joconde: 00000089520 Photographer Renoir, peintre du bonheur : 1841-1919, de Gilles Néret, Köln, Taschen, 2001, p. 380.ISBN 9783822857410
https://commons.m.wikimedia.org/wiki/File:Pierre-Auguste_Renoir_-_Femme_à_la_lettre.jpgQ21730716 Joconde: 00000089509Photographer Unknown
https://upload.wikimedia.org/wikipedia/commons/thumb/3/30/Fleurs_dans_un_vase_Renoir_01.JPG/Miguel Hermoso Cuesta
https://upload.wikimedia.org/wikipedia/commons/thumb/7/75/Pierre-Auguste_Renoir_-_Blonde_à_la_rose_-_c._1915-17.jpg/Q21730762 Joconde: 00000089524 Book scan
https://upload.wikimedia.org/wikipedia/commons/thumb/0/0a/Pierre-Auguste_Renoir_IMG_2118.JPG/Deroravi
https://commons.m.wikimedia.org/wiki/File:Pierre-Auguste_Renoir_-_Bouquet_dans_une_loge.jpgQ21730823 Joconde: 00000089512 Unknown source
https://commons.m.wikimedia.org/wiki/File:Pierre-Auguste_Renoir_-_Bouquet_de_tulipes.jpgQ21730824 Joconde: 00000089521Pierre-Auguste Renoir
https://upload.wikimedia.org/wikipedia/commons/thumb/4/40/Pierre-Auguste_Renoir_-_Deux_fillettes.jpg/Q21730829 Joconde: 00000089508 Renoir : sa vie, son œuvre, de Francesca Castellani (trad. Marie-Christine Gamberini), Paris, Gründ, 1996, p. 197.ISBN 9782700020687
https://upload.wikimedia.org/wikipedia/commons/thumb/f/ff/Pierre-auguste_renoir%2C_pesche%2C_1881-82_ca._02.JPG/Sailko
https://upload.wikimedia.org/wikipedia/commons/thumb/c/c7/Auguste_Renoir_Portrait_d'un_jeune_homme_et_d'une_jeune_fille_(vers_1875-1880)_RF_1963-24.jpg/xiquinhosilva from Cacau
https://upload.wikimedia.org/wikipedia/commons/thumb/b/be/Bouquet_Renoir_01.JPG/Miguel Hermoso

L'ORANGERIE GUIDE

Cuesta
https://upload.wikimedia.org/wikipedia/commons/thumb/4/41/Renoir_jeunes_filles_au_piano_vers_1892.jpg/Own work Author Siren-Com
https://upload.wikimedia.org/wikipedia/commons/thumb/0/0b/Paul_gauguin%2C_paesaggio%2C_1901%2C_02.JPG/Sailko
https://upload.wikimedia.org/wikipedia/commons/thumb/1/19/Chaïm_soutine%2C_bue_e_testa_di_vitello%2C_1923_ca..JPG/Sailko
https://upload.wikimedia.org/wikipedia/commons/thumb/f/fc/Soutine-2014-15.jpg/Photographie numérique
https://upload.wikimedia.org/wikipedia/commons/thumb/f/fc/Maurice_Utrillo_La_Mairie_au_drapeau_(1924)_RF_1960-53.jpg/xiquinhosilva from Cacau
https://upload.wikimedia.org/wikipedia/commons/thumb/8/87/Paysages_de_Sisley%2C_Pissarro_et_Monet_en_1872_(Musée_de_l'Orangerie%2C_Paris)_-_Flickr_-_dalbera.png/Jean-Pierre Dalbéra
https://upload.wikimedia.org/wikipedia/commons/thumb/6/65/Sisley_Orangerie_01.JPG/Miguel Hermoso Cuesta
https://commons.m.wikimedia.org/wiki/File:Paul_guillaume,_il_dittatore,_1929.JPGSailko
https://upload.wikimedia.org/wikipedia/commons/thumb/0/05/Claude_Monet_038.jpg
https://upload.wikimedia.org/wikipedia/commons/thumb/5/51/Paul_Cézanne_-_Le_Déjeuner_sur_l'herbe_(Orangerie).jpg/https://www.cezannecatalogue.com/catalogue/entry.php?id=944
https://upload.wikimedia.org/wikipedia/commons/thumb/0/05/Claude_Monet_038.jpg/The Yorck Project (2002) 10.000 Meisterwerke der Malerei (DVD-ROM), distributed by DIRECTMEDIA Publishing GmbH. ISBN : 3936122202 .
https://upload.wikimedia.org/wikipedia/commons/thumb/c/c3/Claude_Monet_with_his_palette_in_front_of_his_work_'Les_nymphéas'%2C_photo_1920s%2C_attrib._to_Henri_Manuel.jpg/Henri Manuel
https://upload.wikimedia.org/wikipedia/commons/thumb/c/c3/Claude_Monet_with_his_palette_in_front_of_his_work_'Les_nymphéas'%2C_photo_1920s%2C_attrib._to_Henri_Manuel.jpg/Henri Manuel
https://upload.wikimedia.org/wikipedia/commons/thumb/6/66/Claude_Monet_-_The_Water_Lilies_-_Setting_Sun_-_Google_Art_Project.jpg/Q28797622 Joconde: 000PE003985 qAG-qyFHUPm1kg sur l'Institut culturel Google
https://upload.wikimedia.org/wikipedia/commons/thumb/a/a4/Claude_Monet_1899_Nadar_crop.jpg/Nadar
https://upload.wikimedia.org/wikipedia/commons/2/2a/Claude_Monet_-_The_Water_Lilies_-_The_Clouds_-_Google_Art_Project.jpgYQEt9_UVgiL-Og sur l'Institut culturel Google
https://upload.wikimedia.org/wikipedia/commons/thumb/1/17/L'orangeraie%2C_Paris_2008.jpg/ yves Tennevin from La Garde, France
https://upload.wikimedia.org/wikipedia/commons/thumb/d/d8/Musée_de_l'Orangerie%2C_paul_guillaume_rooms_reconstruction_03.JPG/sailko
https://upload.wikimedia.org/wikipedia/commons/thumb/1/19/Musée_de_L'Orangerie%2C_hall.jpg/Brady Brenot
https://upload.wikimedia.org/wikipedia/commons/thumb/5/52/Auguste_Rodin-L'ombre-Orangerie_des_Tuileries.jpg/Yair Haklai
https://upload.wikimedia.org/wikipedia/commons/thumb/f/ff/Tuileries_Rodin_Le_Baiser_120409_1.jpg/Vassil
https://upload.wikimedia.org/wikipedia/commons/thumb/9/97/Auguste_Rodin-Eve-Orangerie_des_Tuileries.jpg/Yair Haklai
https://upload.wikimedia.org/wikipedia/commons/thumb/7/7d/Panoramic_over_the_Tuileries_Gardens.jpg/Eutouring
https://upload.wikimedia.org/wikipedia/commons/thumb/2/26/Costa_d'avorio%2C_baoulé%2C_maschera_zoomorfa.JPG/Sailko
https://commons.m.wikimedia.org/wiki/File:Clémenceau_par_Rodin_Musée_de_l_Orangerie.jpgIbex73
https://upload.wikimedia.org/wikipedia/commons/thumb/6/6a/La_Méditation_by_Auguste_Rodin%2C_Tuileries_2011_002.jpg/couscouschocolat from Issy-Les-Moulineaux, France
https://upload.wikimedia.org/wikipedia/commons/thumb/2/25/Henri_Rousseau%2C_dit_le_Douanier_-_La_Carriole_du_père_Junier_-_Google_Art_Project.jpg/HgGfQAqvKqsWOw at Google Cultural Institute
https://upload.wikimedia.org/wikipedia/commons/thumb/7/71/Henri_Rousseau%2C_dit_le_Douanier_-_The_Wedding_Party_-_Google_Art_Project.jpg/eAGtJRGu8YRJiA at Google Cultural Institute
https://upload.wikimedia.org/wikipedia/commons/thumb/4/46/Amedeo_Modigliani_-_Paul_Guillaume%2C_Novo_Pilota_-_Google_Art_Project.jpg/egGdt6G4tsL9nQat Google Cultural Institute
https://upload.wikimedia.org/wikipedia/commons/thumb/2/25/Amedeo_Modigliani_-_ntonia_-_Google_Art_Project.jpg/7wEYA9DJTAMJ8w at Google Cultural Institute
https://upload.wikimedia.org/wikipedia/commons/thumb/8/86/Avant_du_Tub._Opus_176_(Signac).jpg/Paul Signac
https://upload.wikimedia.org/wikipedia/commons/thumb/6/6d/Concarneau._Pêche_à_la_sardine._Opus_221_(Adagio)_(Signac).jpg/Paul Signac
https://upload.wikimedia.org/wikipedia/commons/thumb/8/84/Signac_—_Étude_pour_le_Portait_de_Félix_Fénéon.jpg/https://amazon.com/Paul-Signac-1863-1935/dp/0300088604
https://upload.wikimedia.org/wikipedia/commons/thumb/b/bc/Colección_Walter-Guillaume.JPG/ Miguel Hermoso Cuesta
https://upload.wikimedia.org/wikipedia/commons/thumb/4/4f/Allée_André_Derain_-_Chennevières-sur-Marne_(FR94)_-_2022-04-09_-_1.jpg/Chabe01
https://commons.m.wikimedia.org/wiki/File:L'Age_d'Or_(1905)_André_Derain_-_TMoCA.jpgCreator:André

L'ORANGERIE GUIDE

Derain
https://www.wikiart.org/en/andre-derain/the-road-1932
https://commons.m.wikimedia.org/wiki/File:Marie_Laurencin,_c.1912,_Paris.jpg
https://commons.m.wikimedia.org/wiki/File:Amedeo_Modigliani_1918_restored.jpg
https://es.m.wikipedia.org/wiki/Archivo:Kees_van_Dongen_1923.jpgAgence de presse Meurisse
https://upload.wikimedia.org/wikipedia/commons/thumb/e/ef/André_Derain_1928.jpg/Agence de presse Meurisse
https://fr.m.wikipedia.org/wiki/Fichier:Pierre-Auguste-Renoir_-_Baigneuse_assise_s'essuyant_une_jambe.jpgUnknown source
https://fr.m.wikipedia.org/wiki/Fichier:Pierre-Auguste_Renoir_-_Femme_au_chapeau.jpg Source inconnue
https://upload.wikimedia.org/wikipedia/commons/thumb/9/95 Musée_de_l'Orangerie_plan_en.svg/Homonihilis
https://upload.wikimedia.org/wikipedia/commons/1/10/Paris_1st.pngMap created by Mark Jaroski for Wikitravel.
https://upload.wikimedia.org/wikipedia/commons/thumb/f/fbParis_1st_arrondissement_map_with_listings.svg/Mark Jaroski
https://upload.wikimedia.org/wikipedia/commons/1/1d/Paris-haussmann-centre.pngCopyright 2004, Mark Jaroski.
https://upload.wikimedia.org/wikipedia/commons/7/73/Metro_1er_arrondissement.png Hmaglione10
https://upload.wikimedia.org/wikipedia/commons/thumb/d/de/Paris_Metro_Ligne_1.svg/Sémhur
https://upload.wikimedia.org/wikipedia/commons/thumb/f/f5/Metro_Paris_M7-plan2030.svg/juliendebrousse
https://upload.wikimedia.org/wikipedia/commons/b/b1/Portrait_of_Henri_Matisse_1933_May_20.jpgCarl Van Vechten Photographs Biblioteca del Congreso de Estados Unidos.
https://upload.wikimedia.org/wikipedia/commons/thumb/9/95 Musée_de_l'Orangerie_plan_en.svg/Homonihilis
https://upload.wikimedia.org/wikipedia/commons/1/10/Paris_1st.pngMap created by Mark Jaroski for Wikitravel.
https://upload.wikimedia.org/wikipedia/commons/thumb/f/fbParis_1st_arrondissement_map_with_listings.svg/Mark Jaroski
https://upload.wikimedia.org/wikipedia/commons/1/1d/Paris-haussmann-centre.pngCopyright 2004, Mark Jaroski.
https://upload.wikimedia.org/wikipedia/commons/7/73/Metro_1er_arrondissement.png Hmaglione10
https://upload.wikimedia.org/wikipedia/commons/thumb/d/de/Paris_Metro_Ligne_1.svg/Sémhur
https://upload.wikimedia.org/wikipedia/commons/thumb/f/f5/Metro_Paris_M7-plan2030.svg/juliendebrousse
https://upload.wikimedia.org/wikipedia/commons/thumb/b/b5/Renoir%2C_Pierre-Auguste%2C_by_Dornac%2C_BNF_Gallica.jpg/Dornac
https://en.m.wikipedia.org/wiki/File:Paul-Cezanne.jpg
https://es.m.wikipedia.org/wiki/Archivo:Portrait_d'Alfred_Sisley.jpg Photographie des Archives Skira
https://upload.wikimedia.org/wikipedia/commons/thumb/4/4f/Paul_Gauguin_111.jpg/826px-Paul_Gauguin_111.jpg(Eloquence)
https://en.m.wikipedia.org/wiki/File:1918,_Soutine,_Self_Portrait.jpgHenry and Rose Pearlman Collection Licensing

www.ingramcontent.com/pod-product-compliance
Lightning Source LLC
Chambersburg PA
CBHW070116230526
45472CB00004B/1287